Marcia,

With all our thoughts
+ prayers, for
VICTORIA,

love,

Lar Maughry, Kathleen Colin

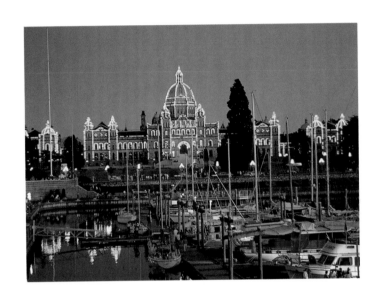

VICTORIA
AND THE SAANICH PENINSULA

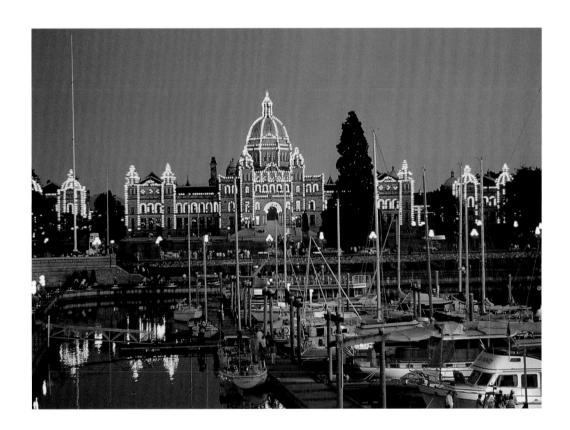

WHITECAP BOOKS

The information in this book is true and complete to the best of our knowledge. All
recommendations are made without guarantee on the part of the author or Whitecap
Books Ltd. The author and publisher disclaim any liability in connection with the use
of this information. For additional information please contact Whitecap Books Ltd.,
351 Lynn Avenue, North Vancouver, BC V7J 2C4.

Text by Tanya Lloyd Kyi
Edited by Elaine Jones
Photo editing by Tanya Lloyd Kyi
Proofread by Lisa Collins
Cover and interior layout by Jacqui Thomas

Printed and bound in Canada

National Library of Canada Cataloguing in Publication Data

Kyi, Tanya Lloyd, 1973–

 Victoria and the Saanich Peninsula

 (Canada series)
 ISBN 1-55285-329-2

 1. Victoria (B.C.)—Pictorial works. 2. Saanich Peninsula (B.C.)—
 Pictorial works. I. Title. II. Series: Kyi, Tanya Lloyd, 1973–
 Canada series.
FC 3846.37.K94 2002 971.1'2804'0222 C2002-910078-X
F1089.5.V6K94 2002

The publisher acknowledges the support of the Canada Council and the Cultural
Services Branch of the Government of British Columbia in making this publication
possible. We acknowledge the financial support of the Government of Canada through
the Book Publishing Industry Development Program for our publishing activities.

For more information on the Canada Series and other Whitecap Books
titles, please visit our web site at www.whitecap.ca.

The quintessential Victoria photograph—the one that remains undeniably the symbol of the city—is the Legislative Buildings at night, lit by more than 3,000 incandescent bulbs. Yet after decades as British Columbia's quiet, discreet—even stuffy—capital city, Victoria is slowly casting aside its tweedy image and welcoming a new diversity to its flower-bedecked streets. While some visitors still sip formal afternoon tea at the Empress Hotel, others enjoy a traditional Cantonese business lunch—dim sum—a few blocks away. Shops on Government Street offer authentic tartans, but just next door sightseers can choose a piece of original First Nations carving, a Guatemalan sweater, a hemp shirt, or freshly ground organic coffee. City venues, from the grand McPherson Theatre to the intimate Belfry, present avant-garde contemporary plays from Canada and around the world, alongside eternal crowd pleasers such as *No Sex Please, We're British*.

Fortunately, the setting for this flourishing city of more than 330,000 people remains largely unchanged; Victoria has one of the most scenic locations in all of British Columbia. Beacon Hill Park protects endangered Garry oak meadows, migrating grey whales surface off the rocky bluffs of East Sooke Regional Park, and salmon churn upstream along the Goldstream River. City and regional preserves protect sights ranging from the forested slopes of Mount Douglas to the elaborate railway trestles that are now part of the Galloping Goose Trail. Students of architecture find the city's streets fascinating, from turreted Craigdarroch Castle to quaint nineteenth-century homes.

Like the landscape, some of the best parts of southern Vancouver Island culture remain unchanged. Buskers in the Inner Harbour greet people with bagpipe tunes and guitar ballads. Horse-drawn carriages rumble through the streets of James Bay and local pubs offer their own special brews. Farms continue to offer fresh eggs or daffodils at roadside stands on the Saanich Peninsula. And visitors still feel the warm embrace of traditional Victoria hospitality.

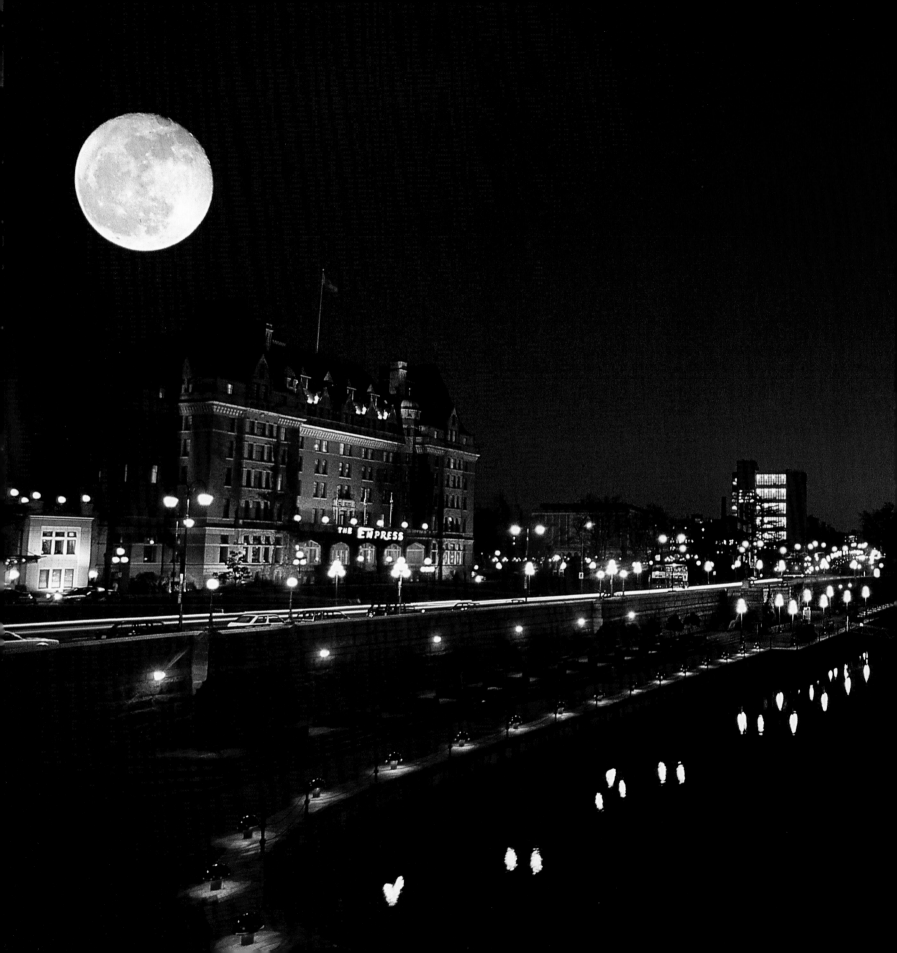

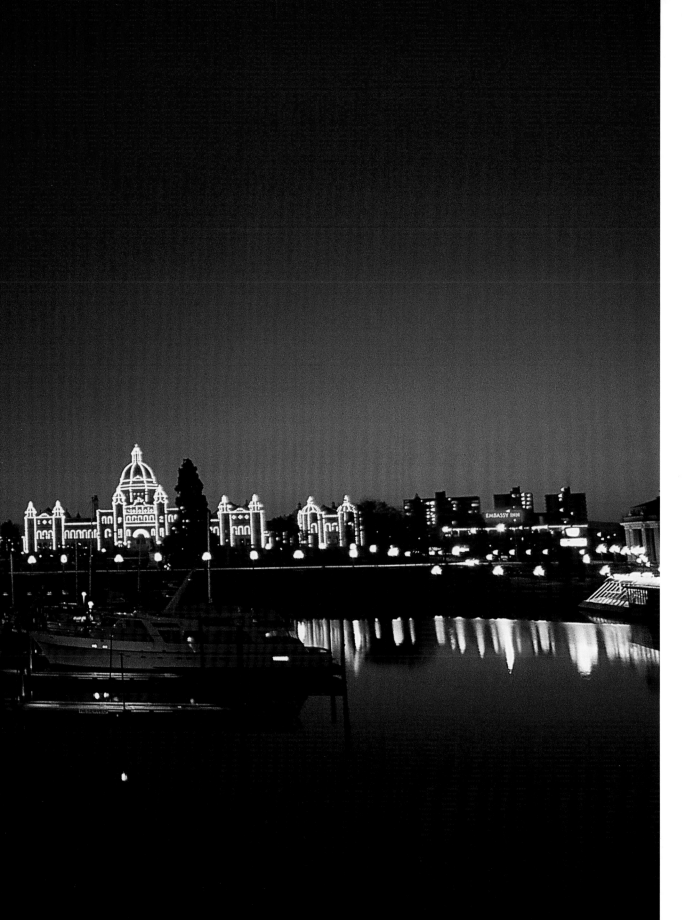

Although the Beacon Hill area had been settled by First Nations people centuries before, Victoria as we know it was born when James Douglas sailed into the harbour in March 1843. He declared the land perfect for his new outpost, Fort Victoria, and the stockades were under construction by June.

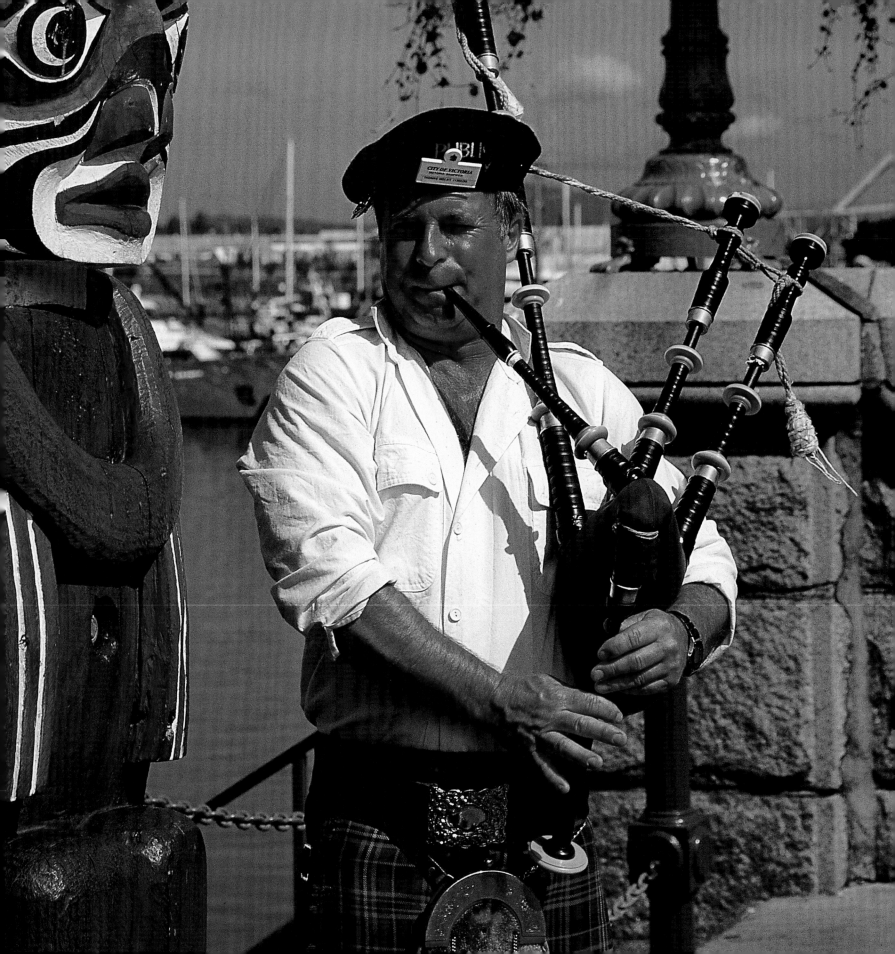

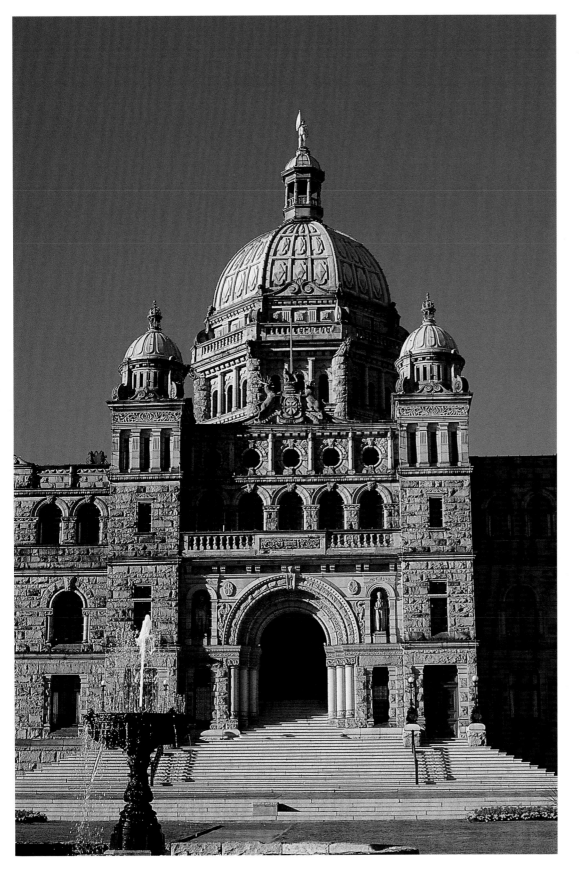

Twenty-five-year-old Francis Mawson Rattenbury, an architect who had recently arrived in Canada from Britain, competed against 67 others to win the contract to design British Columbia's legislative buildings. Completed in 1898, the buildings cost about a million dollars—almost twice Rattenbury's original estimate.

FACING PAGE—
This image of a Scottish bagpiper playing in the shadow of a First Nations totem pole captures the multicultural influences that permeate the city. Victoria's original native population and British settlers were soon joined by immigrants from around the world.

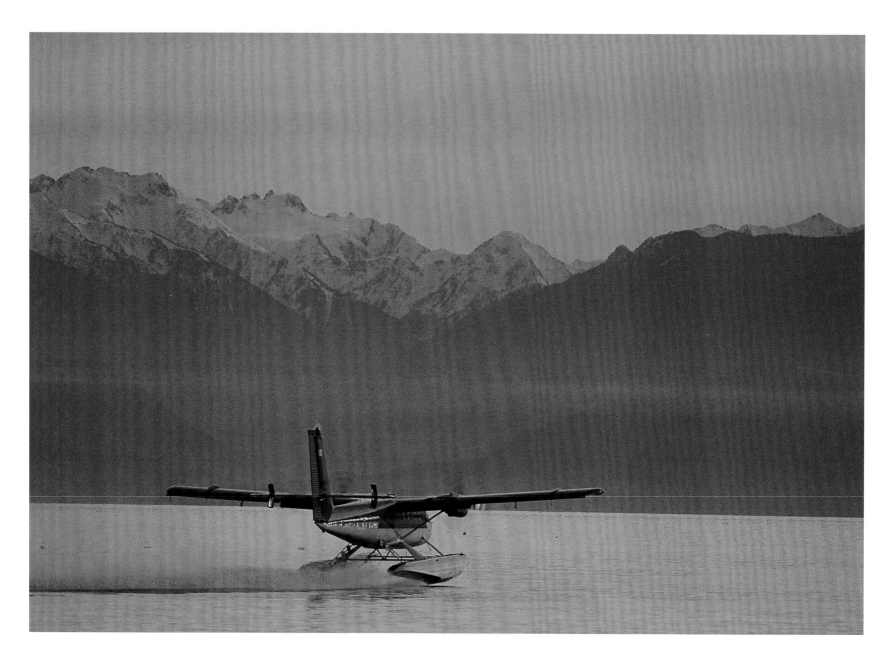

Victoria's Inner Harbour is a place of constant motion, with seaplanes landing and taking off, ferries loading Seattle-bound passengers, and harbour tour boats churning along the shores. In the 1800s, Victoria was the busiest port in the province, but the arrival of the railway in Vancouver left the capital city in second place.

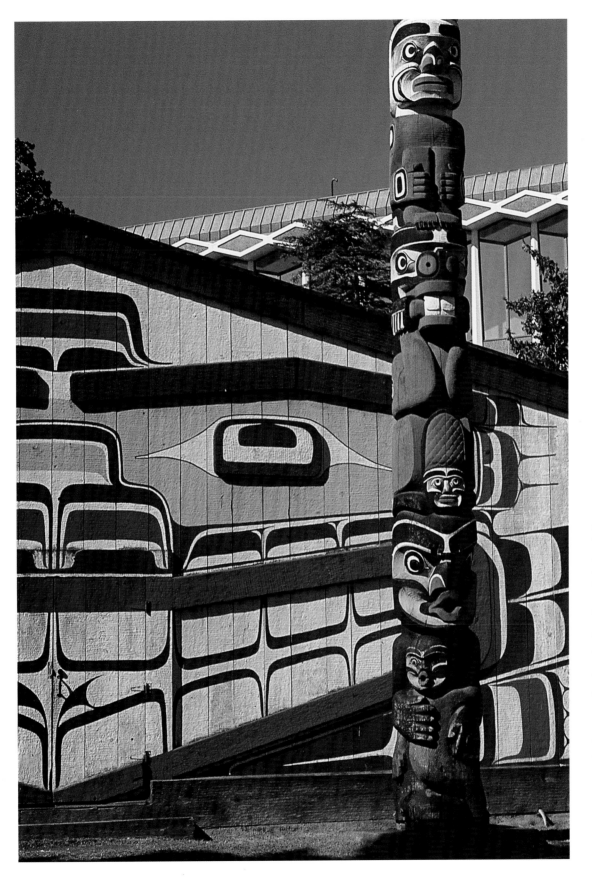

Since 1962, First Nations carvers have worked at Thunderbird Park—often where visitors could watch—to recreate the traditional poles of their past. The displays include grave figures, house posts, and memorial, heraldic, and mortuary poles.

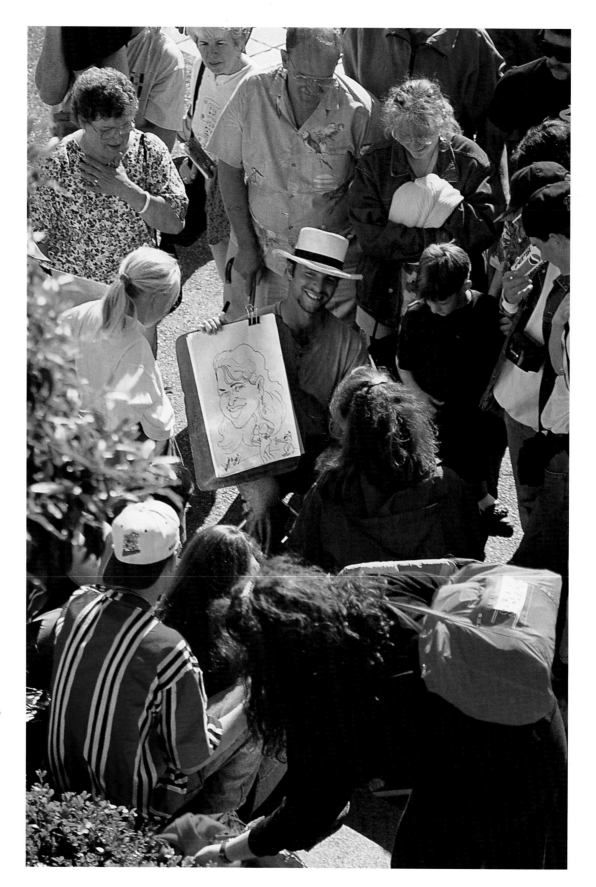

Strolling along the Inner Harbour, sightseers can listen to street musicians, have their portraits sketched, buy balloon animals, or watch a painted mime—different entertainers set up shop here each day.

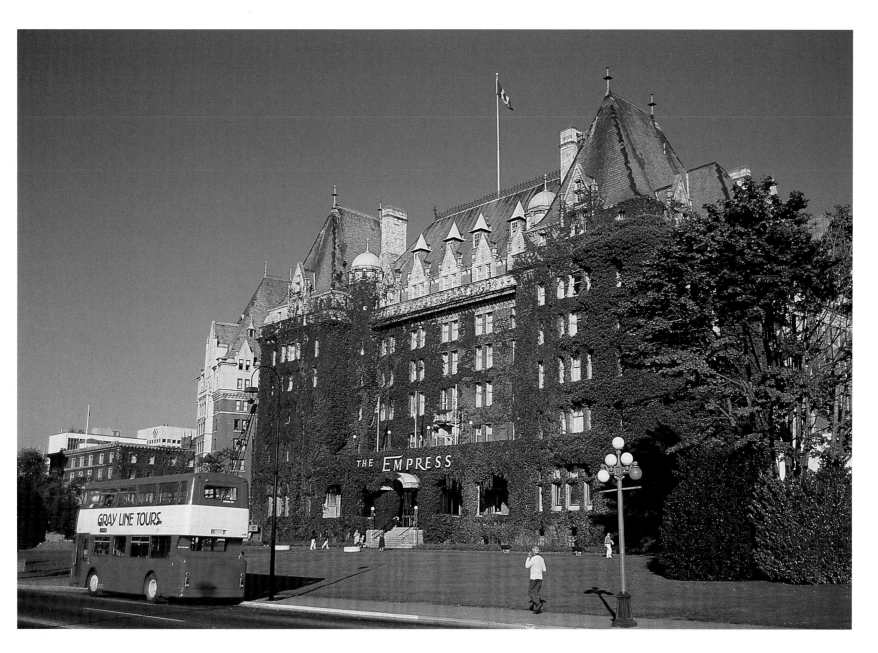

Designed by Francis Mawson Rattenbury, who also created the Legislative Buildings next door, the Empress welcomed its first guests in 1908. More than 75,000 visitors enjoy afternoon tea here each year.

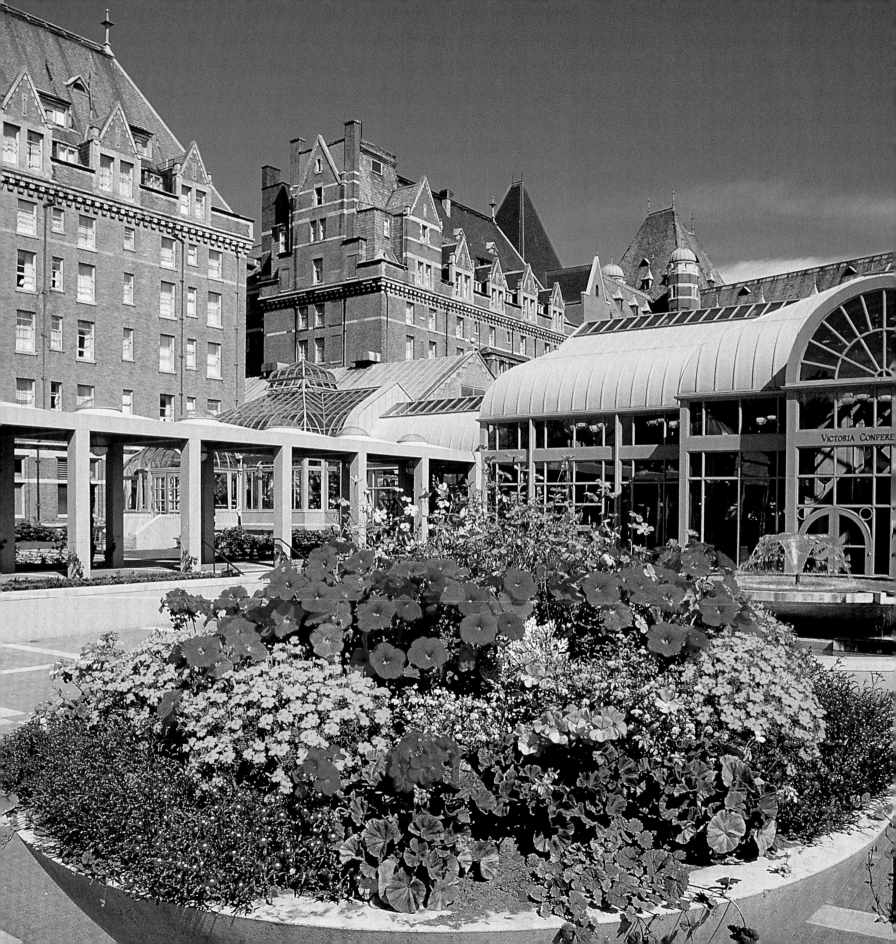

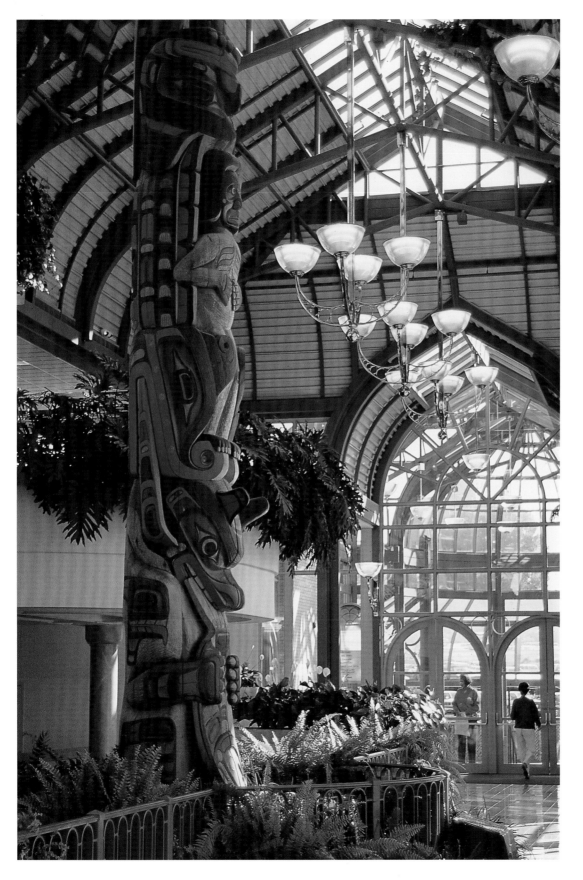

The artwork within the Victoria Conference Centre represents the diverse First Nations cultures of the Pacific coast. The artists who contributed works to the centre include Tony Hunt of the Kwagiulth people, Nuu-chah-nulth carver Art Thompson, Don Yeomans from the Haida Gwai in the Queen Charlotte Islands, and Coast Salish artist Susan Point.

FACING PAGE–
The Victoria Conference Centre, attached to the Empress Hotel, opened its doors in 1989. It features facilities for small business meetings as well as large-scale conference rooms designed for up to 1,500 delegates.

15

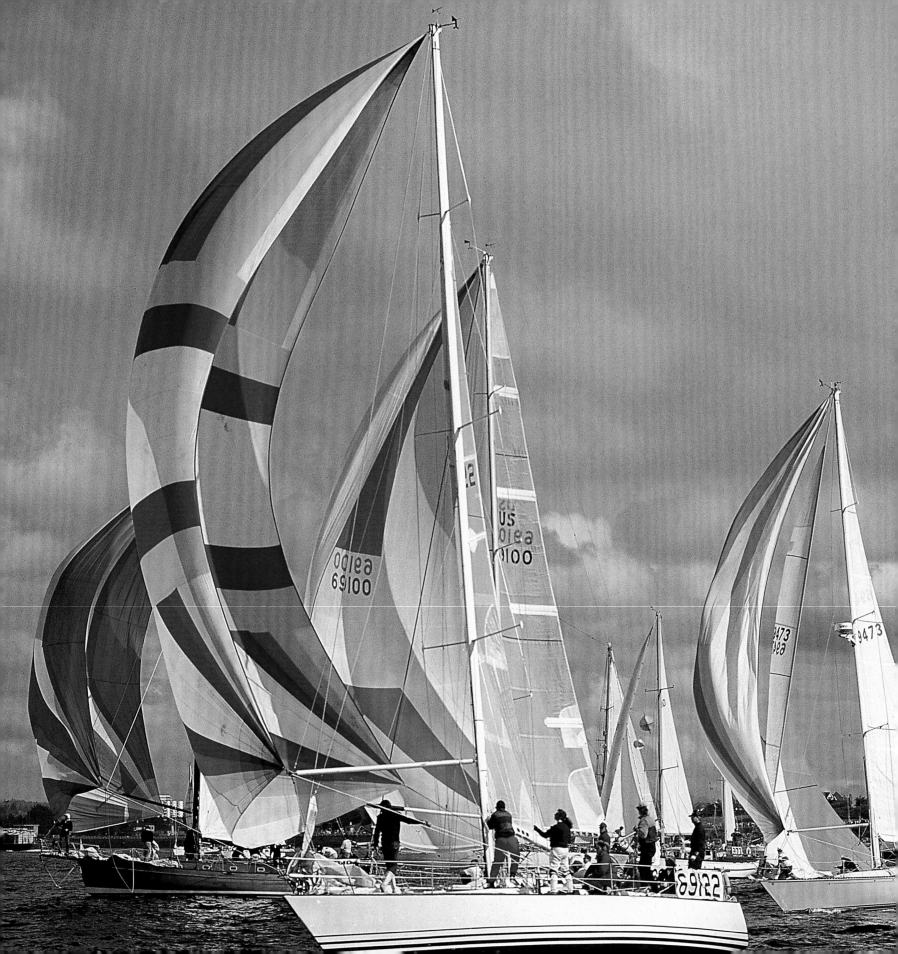

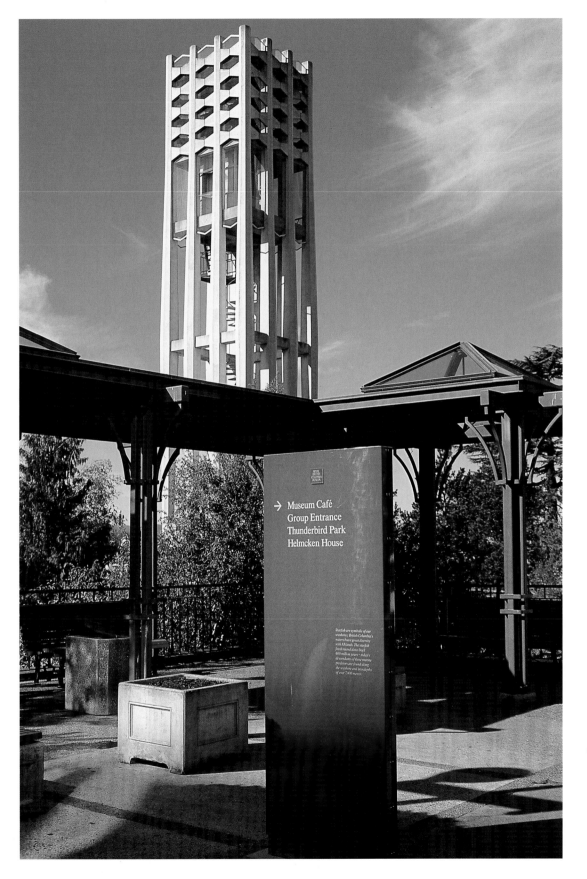

→ Museum Café
Group Entrance
Thunderbird Park
Helmcken House

Donated by Dutch-Canadians in celebration of Canada's anniversary, the Centennial Carillon stands before the Royal British Columbia Museum. Exhibits within the museum showcase First Nations artifacts, the industrial development of the province, British Columbia's natural history, and more.

FACING PAGE—
For more than half a century, the Swiftsure International Yacht Race has drawn sailors from around the world. In the headline event, vessels race for 137 miles from Victoria around the lightship on Swiftsure Bank, at the entrance to the Strait of Juan de Fuca. The route takes even the fastest yachts almost 24 hours.

17

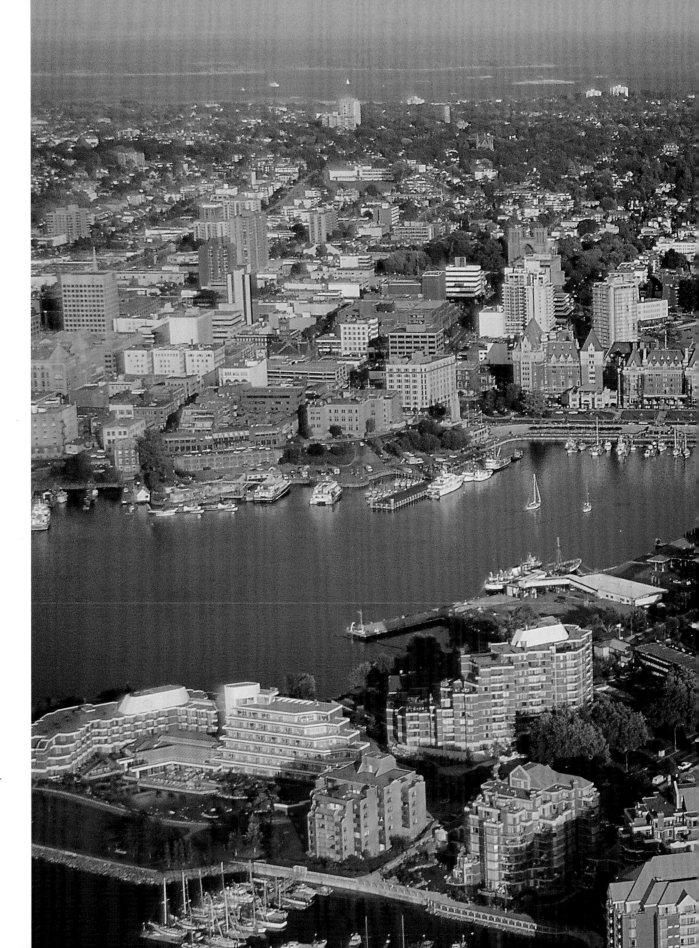

The early settlement of Victoria was vital to Britain's claim on Vancouver Island. The crown granted the Hudson's Bay Company a trading monopoly over the island in 1849, on the condition that the company actively encourage immigration and settlement.

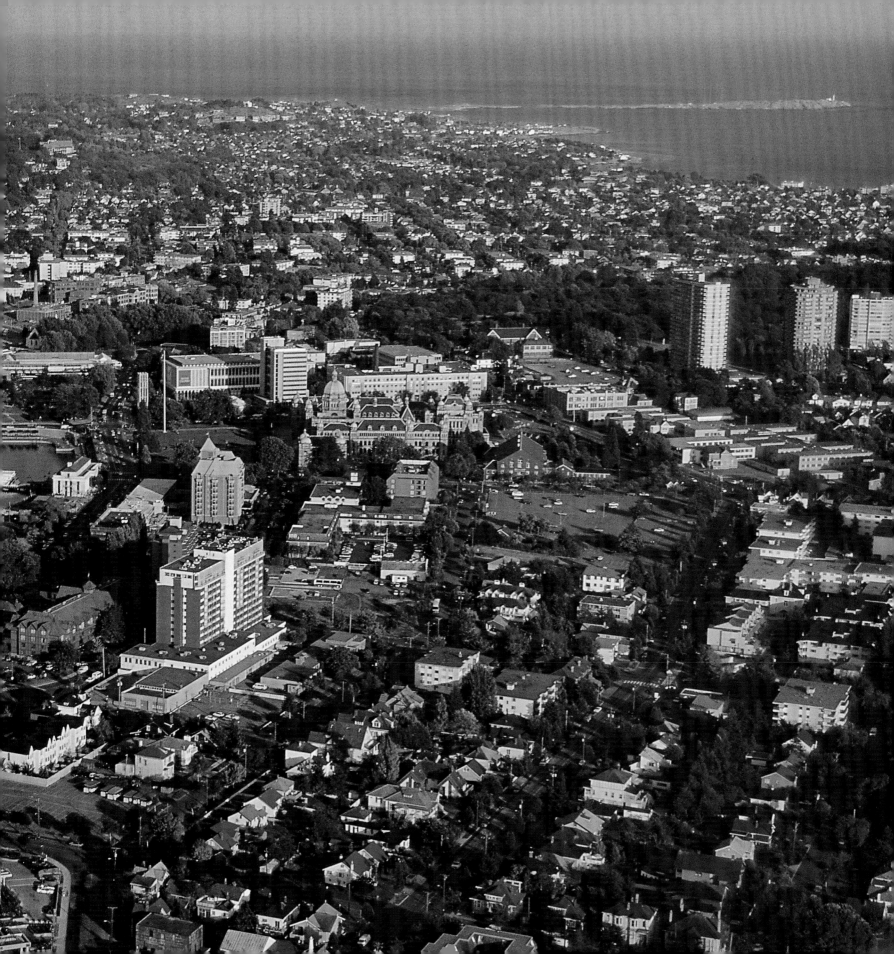

Today a pleasant rest stop in Victoria's downtown district, Bastion Square was once part of Fort Victoria's defences and the site of the local gallows. Matthew Baillie Begbie—the "hanging judge" of the late 1800s—sent many unfortunate prisoners to their deaths here.

FACING PAGE—
Victoria's nineteenth-century law courts are now home to the Maritime Museum of British Columbia. Exhibits examine the themes of exploration, commerce, adventure, passenger travel, government fleets, and the B.C. Ferries throughout the province's history.

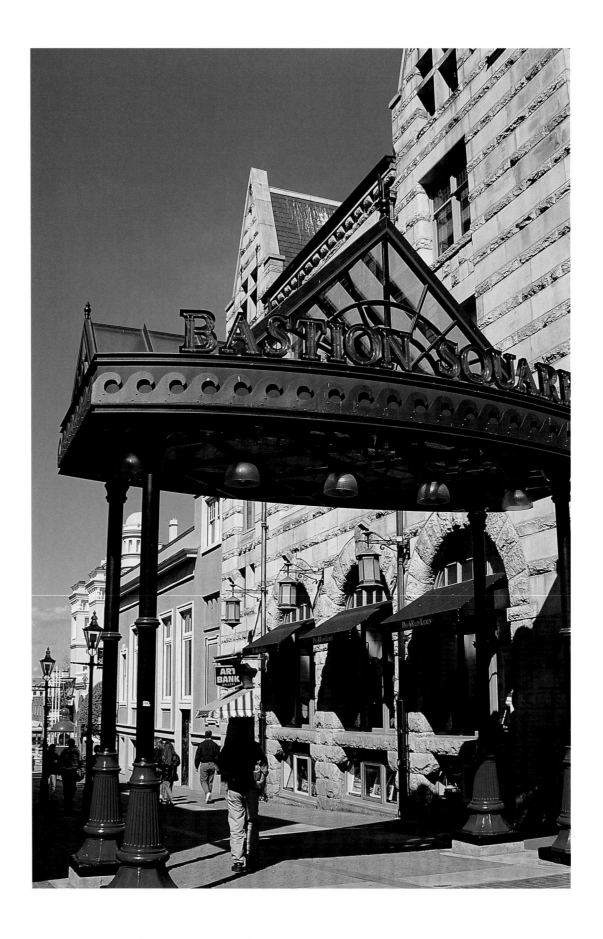

Part tourist destination and part government town, Victoria is also a community of closely knit neighbourhoods. Greater Victoria, including Oak Bay, Saanich, and Esquimalt, is home to more than 300,000 people.

FACING PAGE—
British-style pubs still dot the neighbourhoods of Victoria, but in recent years they have been joined by European delis, Asian eateries, health-food cafés, pasta bars, and tea rooms. Long, sunny summers and the mildest climate in Canada make this the ideal place to dine on an outdoor patio.

23

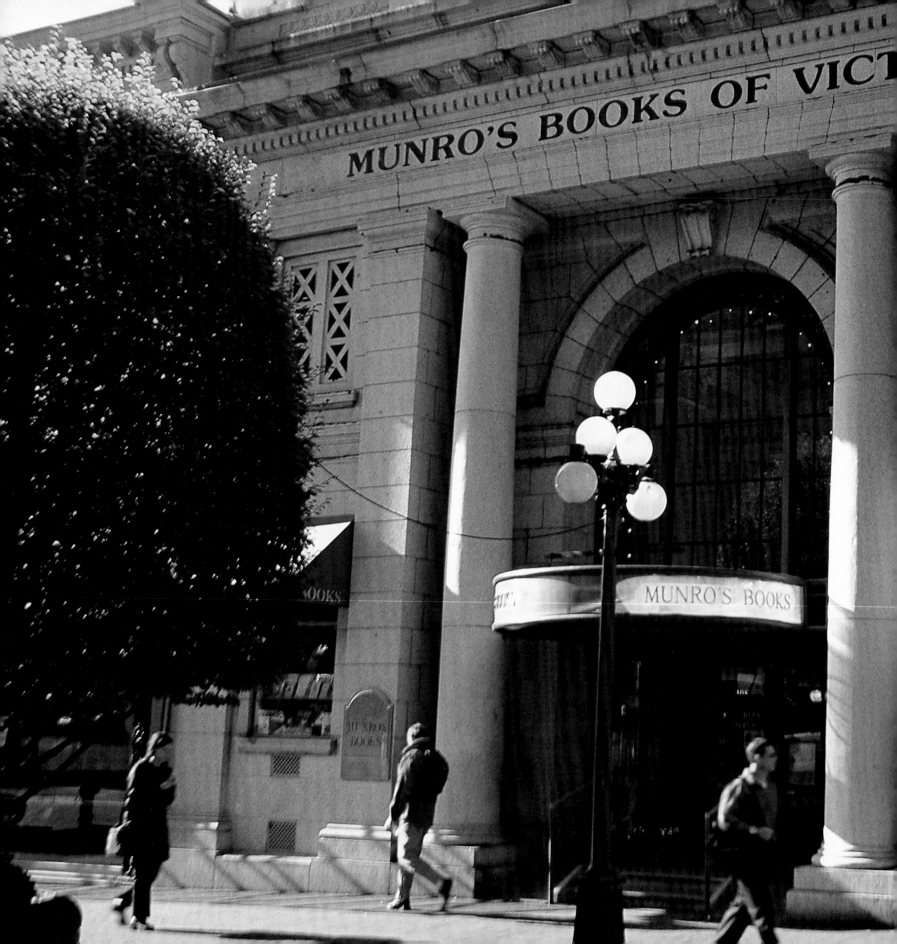

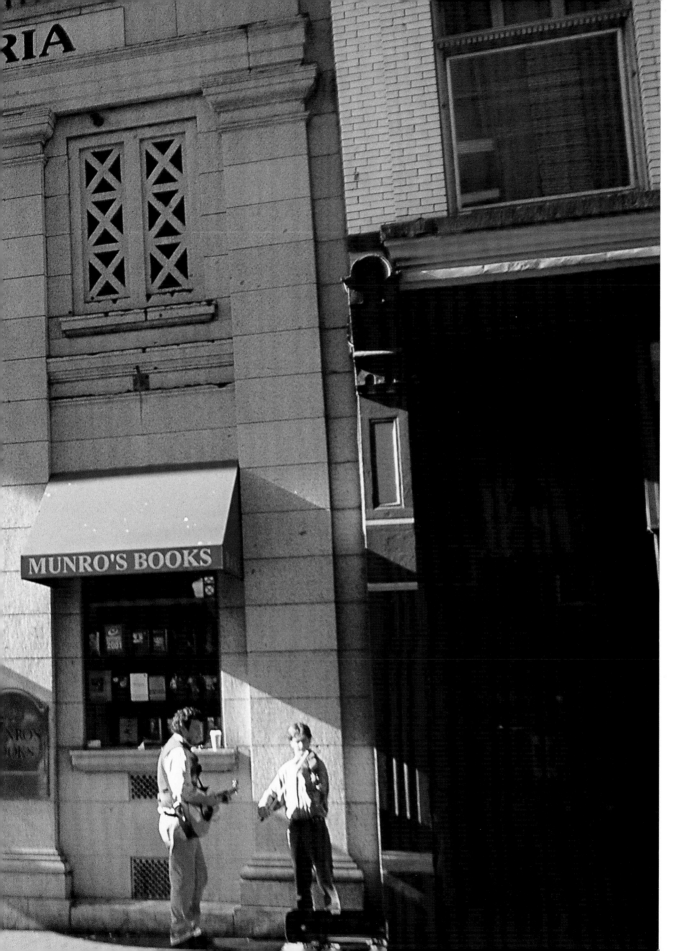

Jim and Alice Munro opened Munro's Books in 1963, and a Victoria institution was born. The store moved to its present Government Street location in 1984 and has since earned a reputation as one of the best bookstores in the nation. The building, built in 1909 for the Royal Bank, has won two heritage awards for restoration.

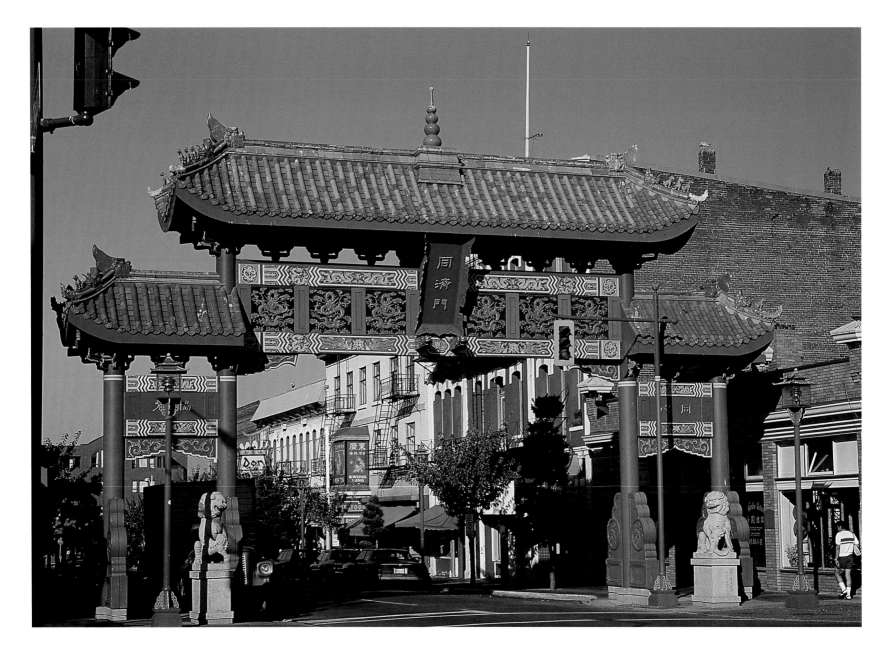

Through the Gate of Harmonious Interest lies Victoria's Chinatown.
The oldest Chinatown in Canada, this neighbourhood grew quickly
after the first Chinese gold miners from California landed in 1858. The
federal government named this a Canadian heritage district in 1996.

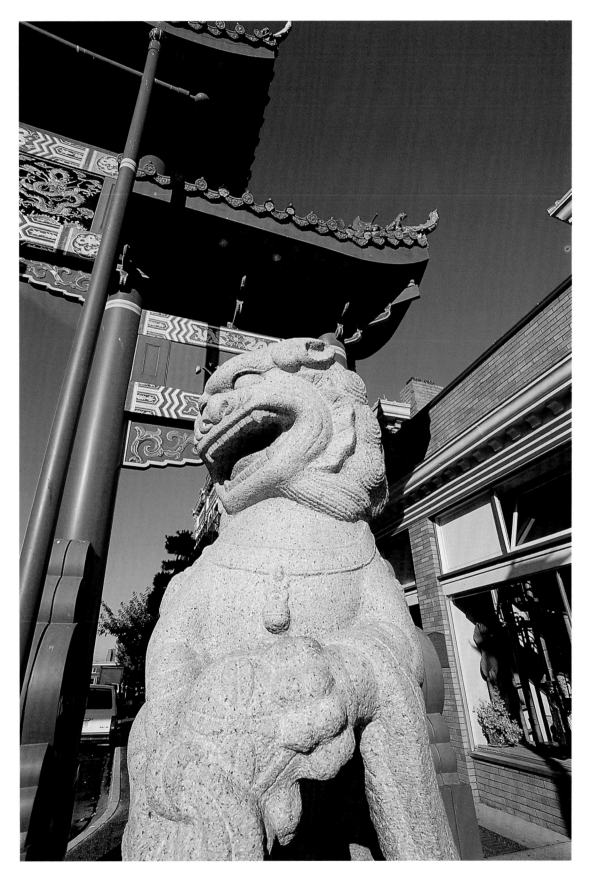

Twin lions guard the Gate of Harmonious Interest, or Tong Ji Men, an arch built across Fisgard Street in 1981 to symbolize co-operation between cultures. This was the first such gate in the nation and marks a neighbourhood once home to about 3,500 people—the largest Chinatown north of San Francisco.

Fan Tan Alley, named for a popular betting game, commemorates a time when Chinatown was home to gambling dens—many of them lining this narrow street—and at least 10 opium factories. Manufacturing and selling opium was legal in B.C. until 1908.

FACING PAGE—
Designed in 1875, begun in 1878, and completed more than a decade later, Victoria's City Hall is the ornate and stylized vision of architect John Teague. The clock adorning the central tower has kept time since May 5, 1891.

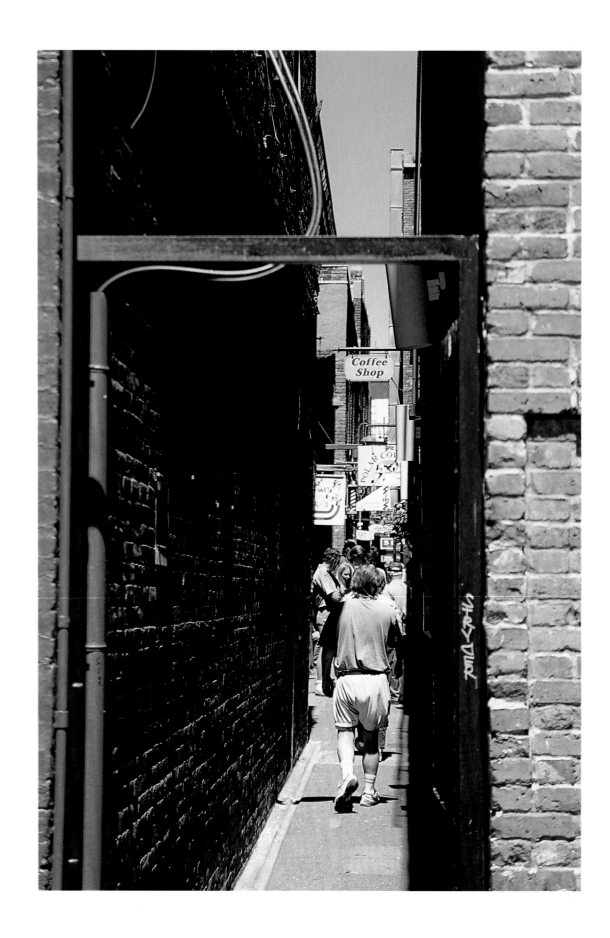

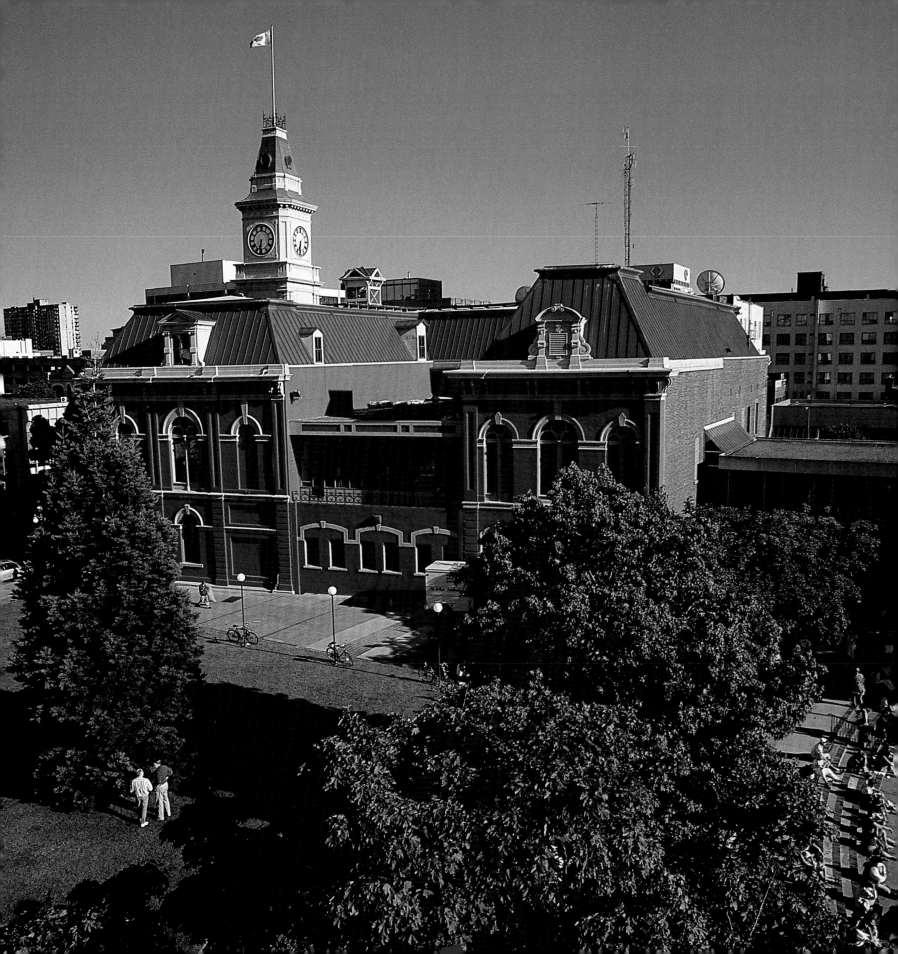

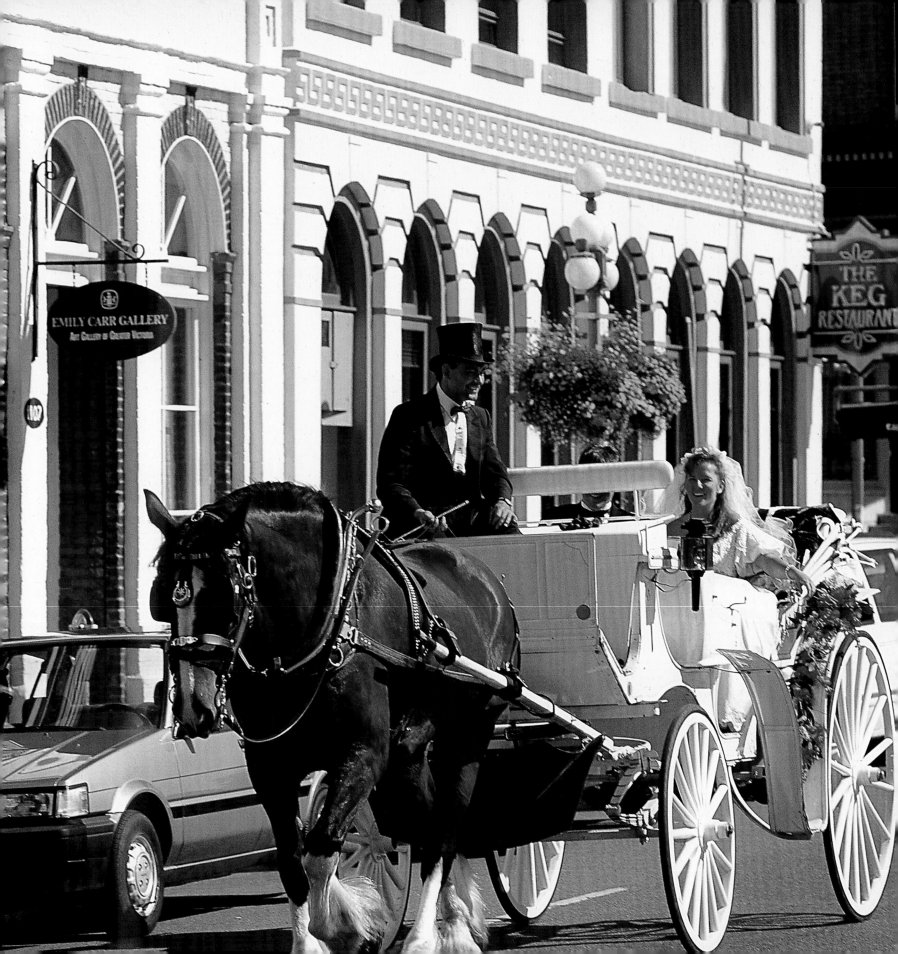

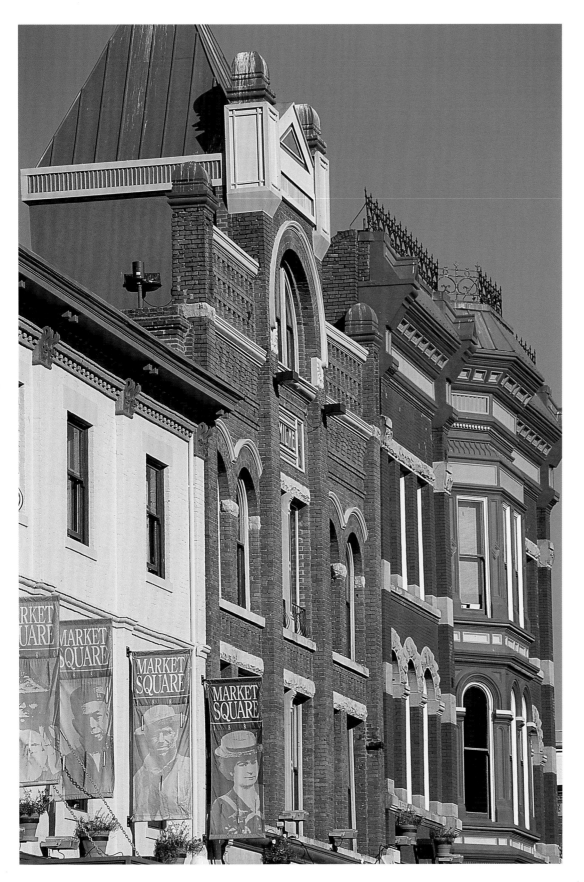

Ninety saloons once lined Johnson Street in Victoria's Old Town. Today, Market Square incorporates nine restored heritage buildings in a whimsical shopping plaza showcasing the wares of 45 shops and restaurants.

FACING PAGE—
The ideal time for a marriage proposal is during a romantic horse and carriage ride through the Inner Harbour and Beacon Hill Park. Anton Henderson offered the first carriage rides in Victoria in 1903.

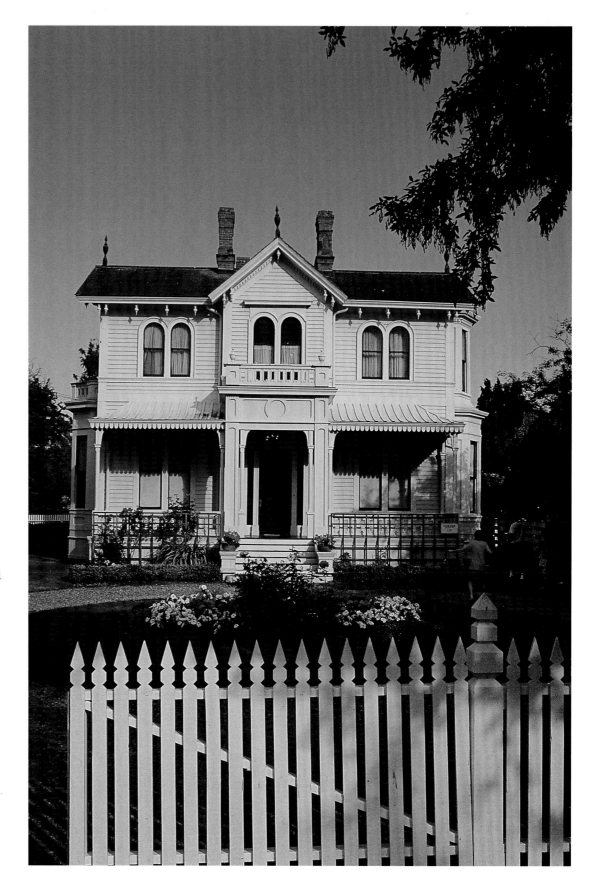

Artist and author Emily Carr was born and raised in this 1864 James Bay home, built for her father Richard Carr. Now recognized as one of British Columbia's most famous artists, Carr spent much of her life in relative obscurity, teaching, running a boarding house, and travelling extensively along the west coast.

A student escapes the library on a spring day to study on the bluffs of Beacon Hill Park, overlooking the Strait of Juan de Fuca. The mountains of Washington's Olympic National Park are visible from the bluffs on clear days.

Victoria's largest park, Beacon Hill includes both formal, manicured gardens featuring 30,000 lovingly tended annuals, and open meadows protecting native species such as Garry oak and arbutus. Much of the park was created by Scottish-born landscape architect John Blair.

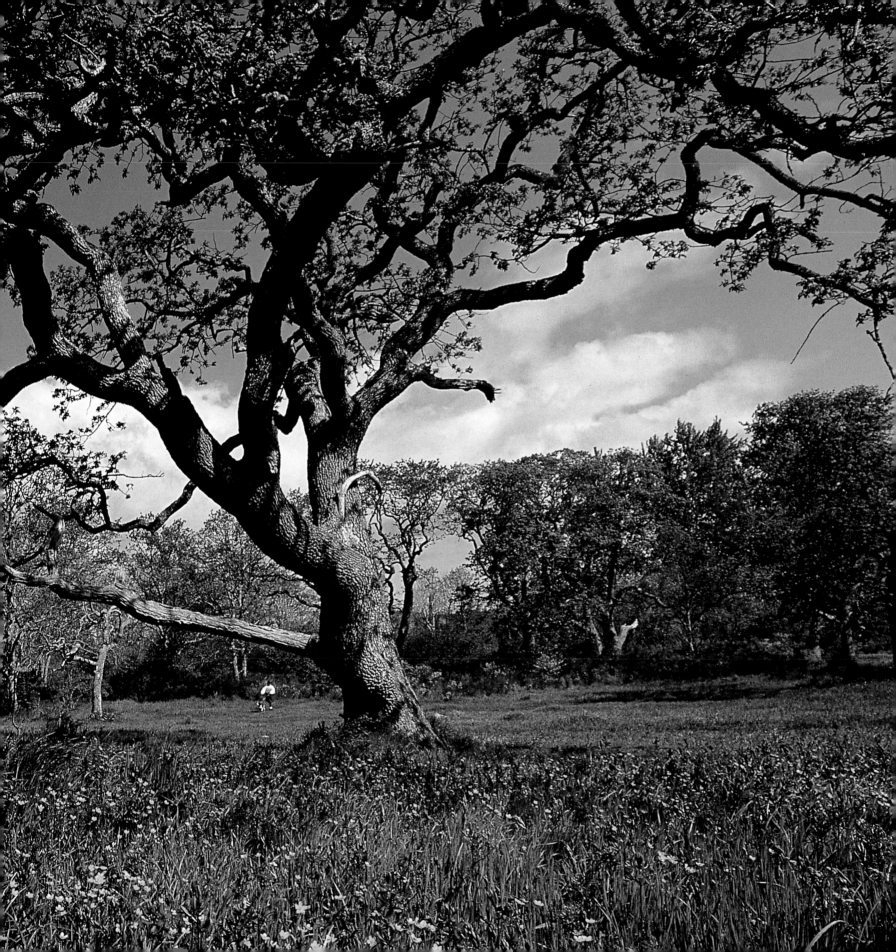

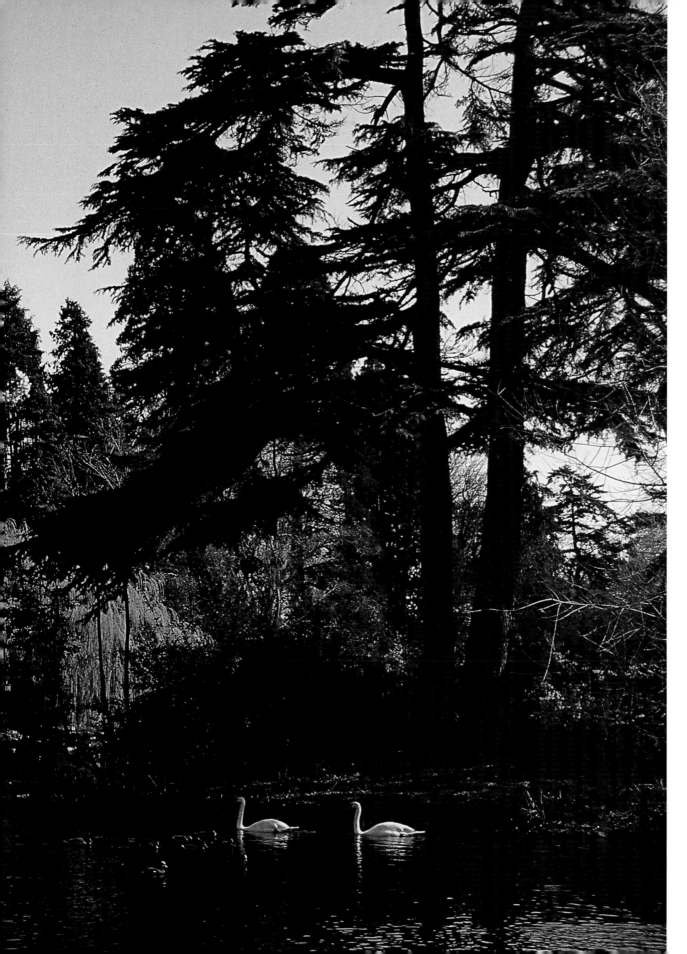

Beacon Hill Park was named for two masts set atop the bluffs in the nineteenth century, to help guide mariners into Victoria's harbour. The 75-hectare (185-acre) preserve was set aside as parkland by Victoria's founder, James Douglas, in 1858.

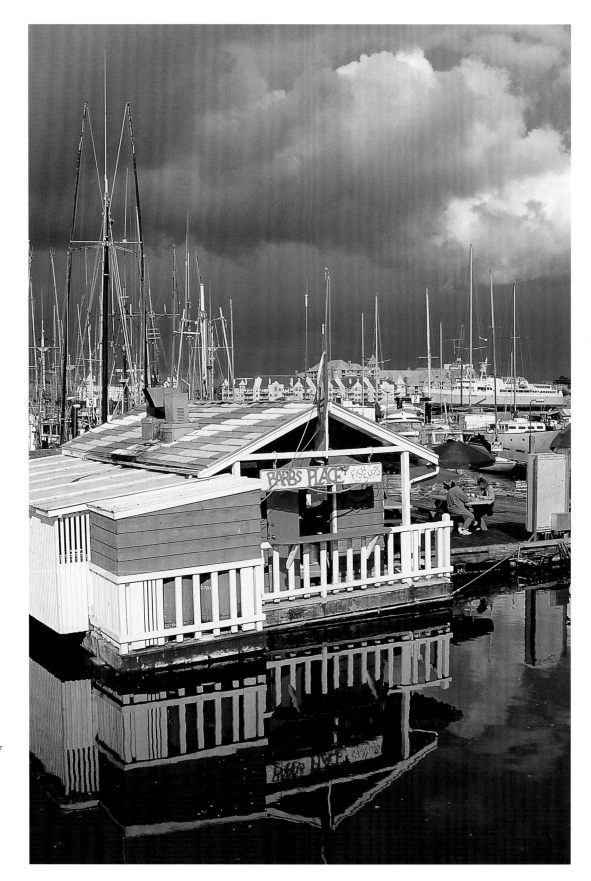

Oyster burgers, halibut and cod fillets, and home-cut fries, all served wrapped in newspaper—Barb's Place Fish and Chips is a favourite dinner spot for locals. The eatery is actually a floating shack, part of Fisherman's Wharf.

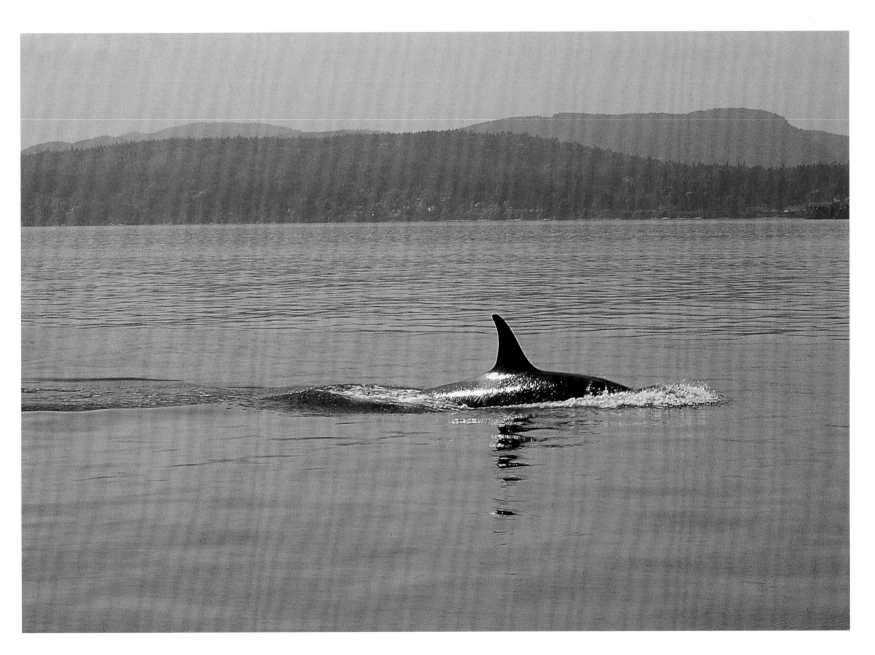

Scientists can identify each orca by its dorsal fin and the grey patch, called the saddle patch, behind. The resident pods that remain in the waters off Vancouver Island year-round feed mainly on fish, while transient orcas hunt marine mammals.

Just a few blocks from Quadra Street, Playfair Park is known for its rhododendrons, which display a profusion of red and pink blooms each spring. There are more than 1,200 flowering plants within the park.

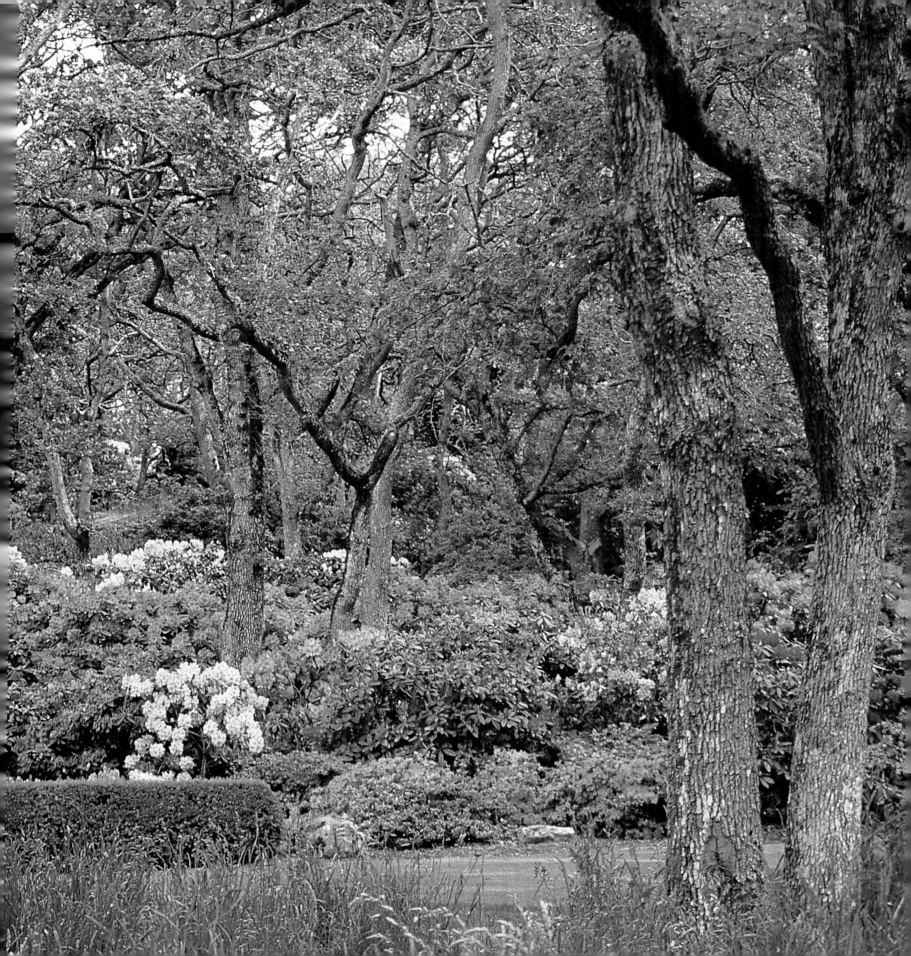

Native to Vancouver Island and protected in most municipalities, Garry oaks are part of a complex ecosystem, including wild-flowers such as camas, Easter lilies, buttercups, and chocolate lilies. Some of these trees are 400 years old and more than 30 metres (100 feet) high.

FACING PAGE—
In the mid-1850s, only a few hundred people called Victoria home. That changed instantly when the *Commodore* arrived in the harbour on April 25, 1858. More than 400 prospectors disembarked, en route to the newly discovered gold-fields of the Cariboo. More than 20,000 more arrived in the following weeks.

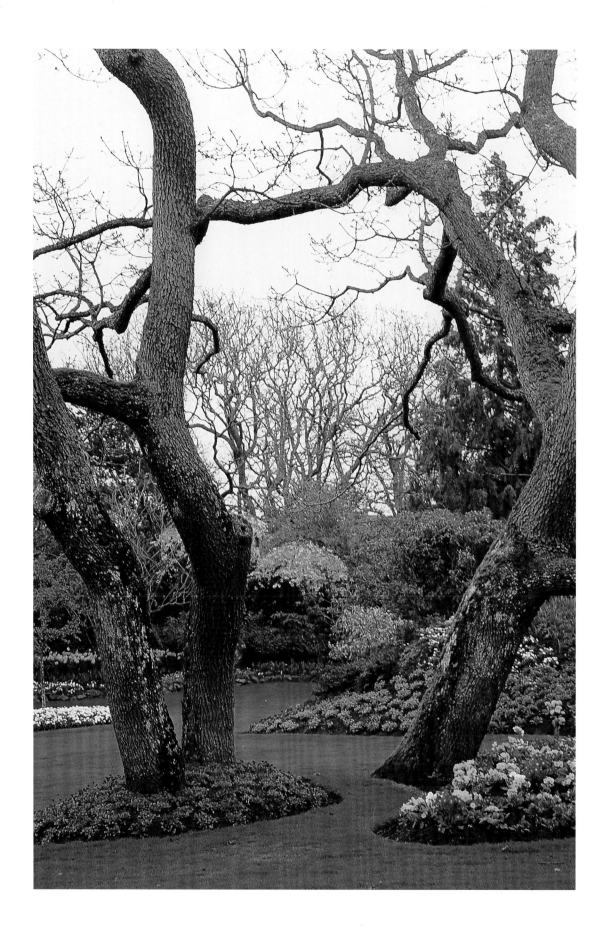

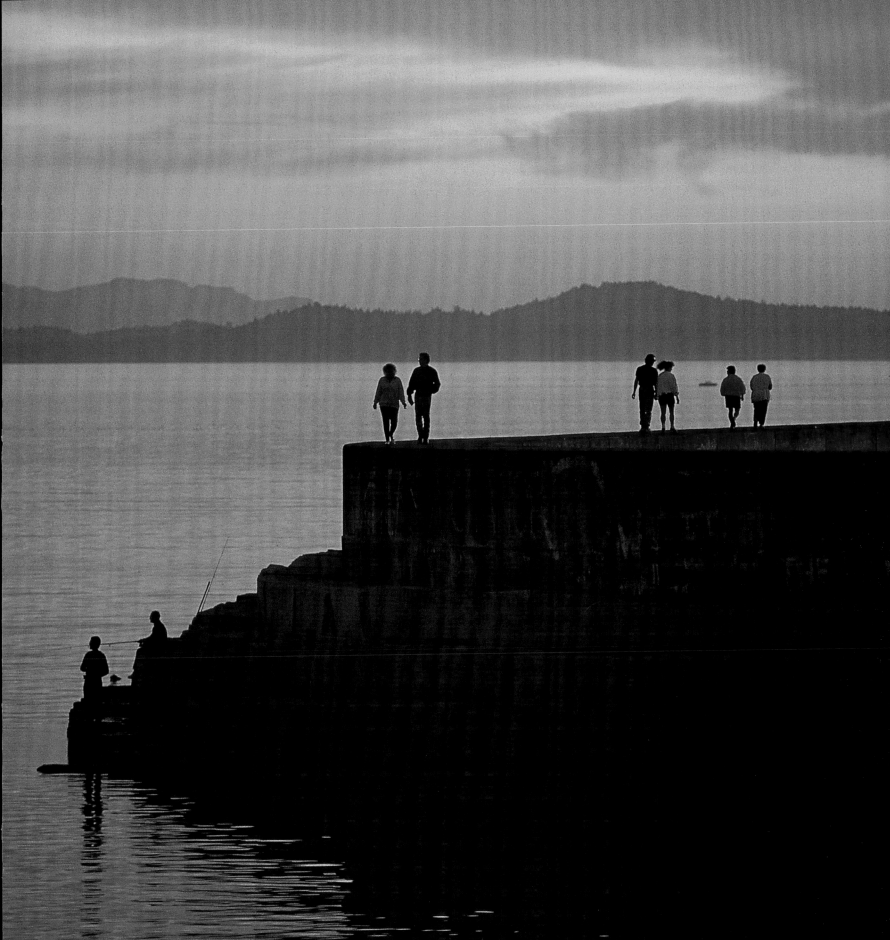

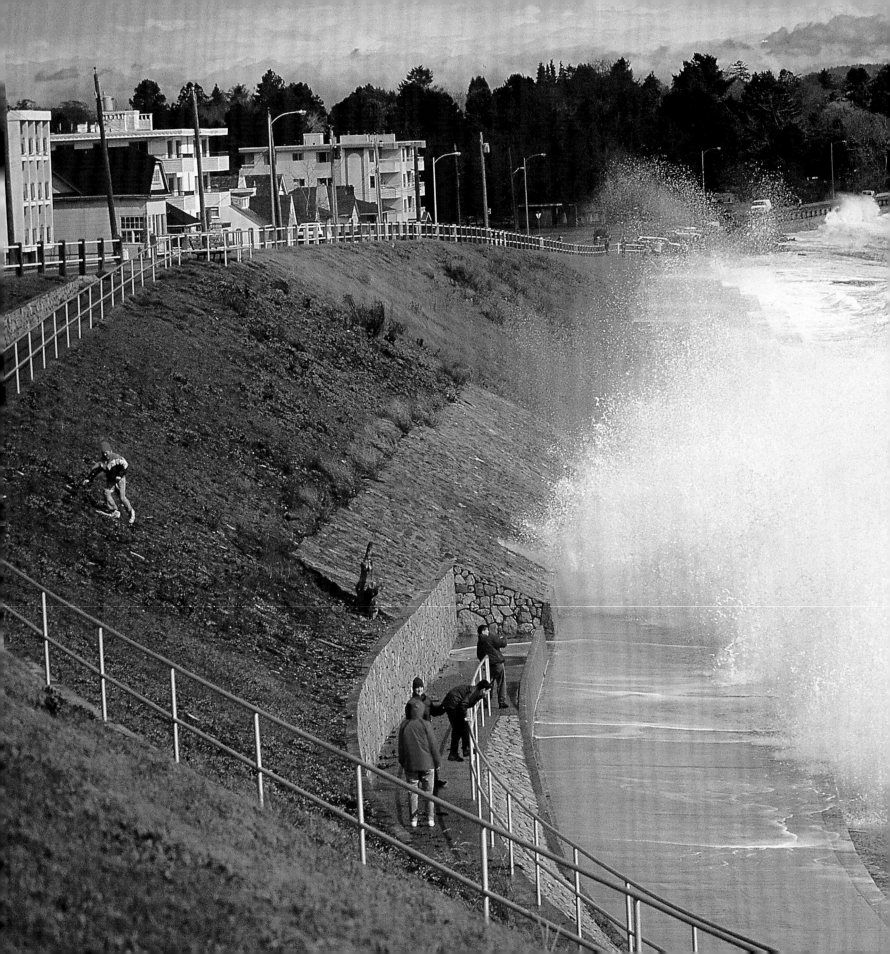

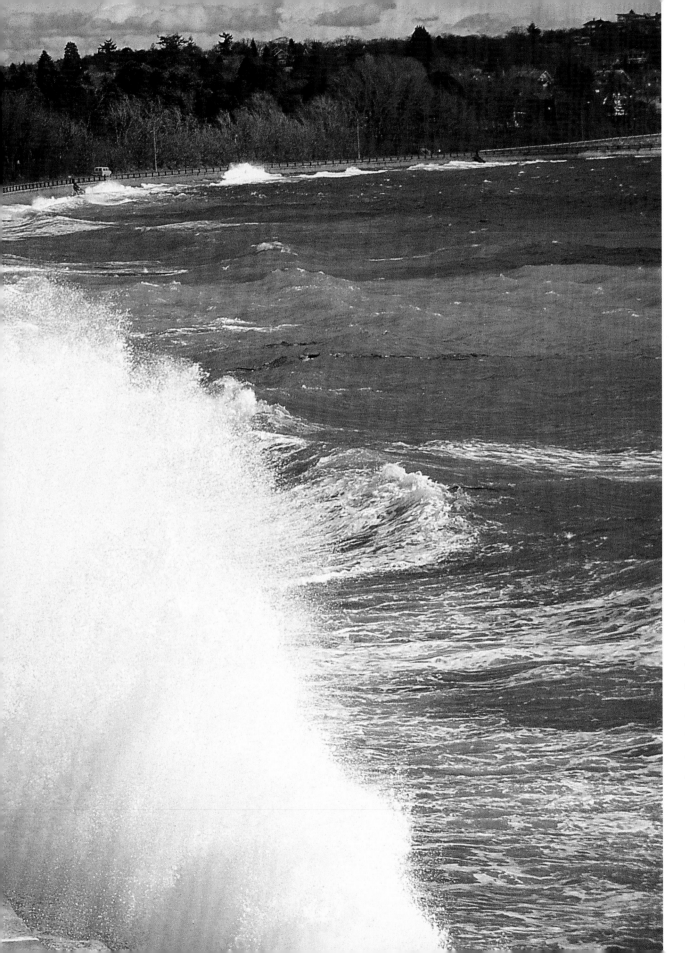

Winter storms whip
the waters off Ross
Bay into a frenzy.
While city officials
close the nearby
roads and warn
people away, storm-
watchers dare to
stand in the spray
of the breakers.

45

The waters off the southern tip of Vancouver Island were a rich source of food for Coast Salish people who once lived in villages along the shore. They gathered abundant shellfish and seaweed from along the rocks, hunted sea mammals, and fished for salmon, halibut, cod, snapper, and herring.

The fortune amassed by Scottish coal baron Robert Dunsmuir is reflected in Craigdarroch Castle's 39 rooms, stained glass windows, intricate woodwork, and lavish Victorian era furnishings. He died before the castle's completion in 1890, leaving his estate to his wife, Joan. Today, visitors can take tours of the castle.

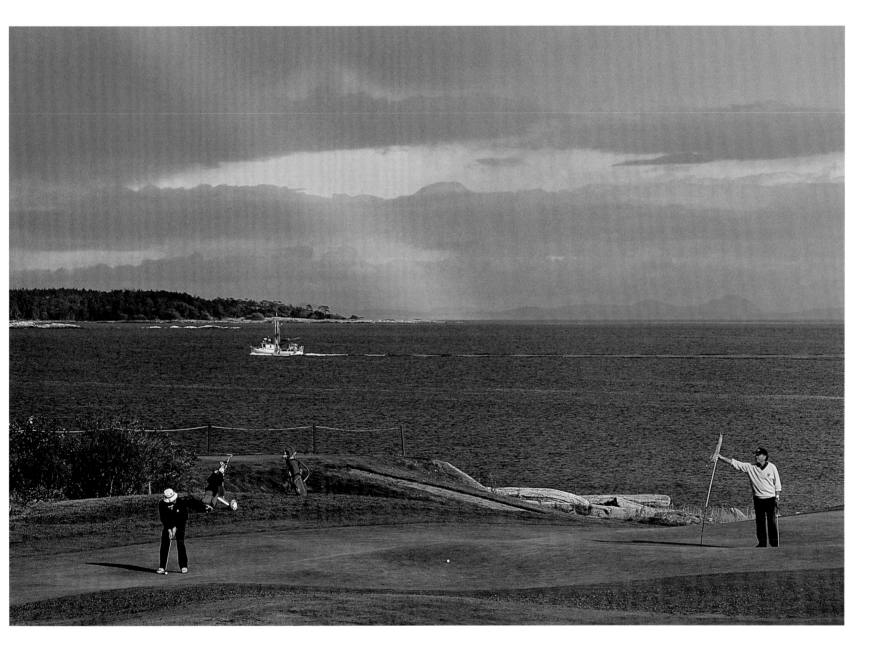

Most of the 50 golf courses on Vancouver Island are within a short drive of downtown Victoria, some bordering the Strait of Juan de Fuca, and others offering panoramic views of the island's mountains. Olympic View, one of the best, boasts two waterfalls and 12 lakes.

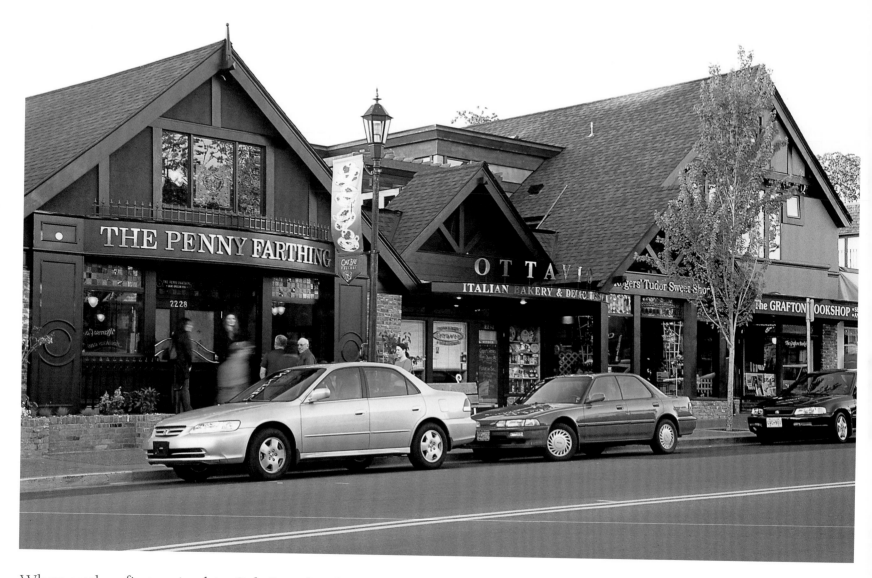

When settlers first arrived in Oak Bay, the shore was lined with towering oaks—thus the community's name. Today, Oak Bay Village is the most traditional of the city's neighbourhoods, a quaint collection of shops and tea houses surrounded by stately heritage homes, many built in the early 1900s.

For 40 years, Oak Bay residents have celebrated summer each June with the Oak Bay Tea Party, a festival of food and entertainment. Children flock to the midway at Willows Beach, cotton candy and caramel apples in hand.

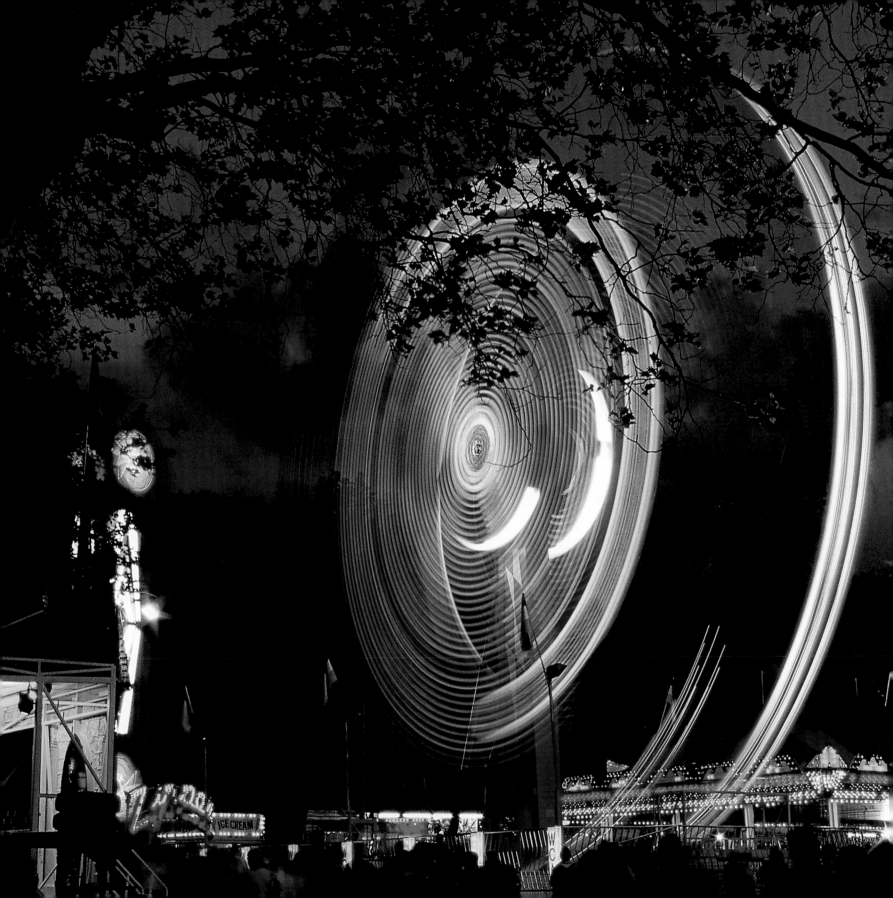

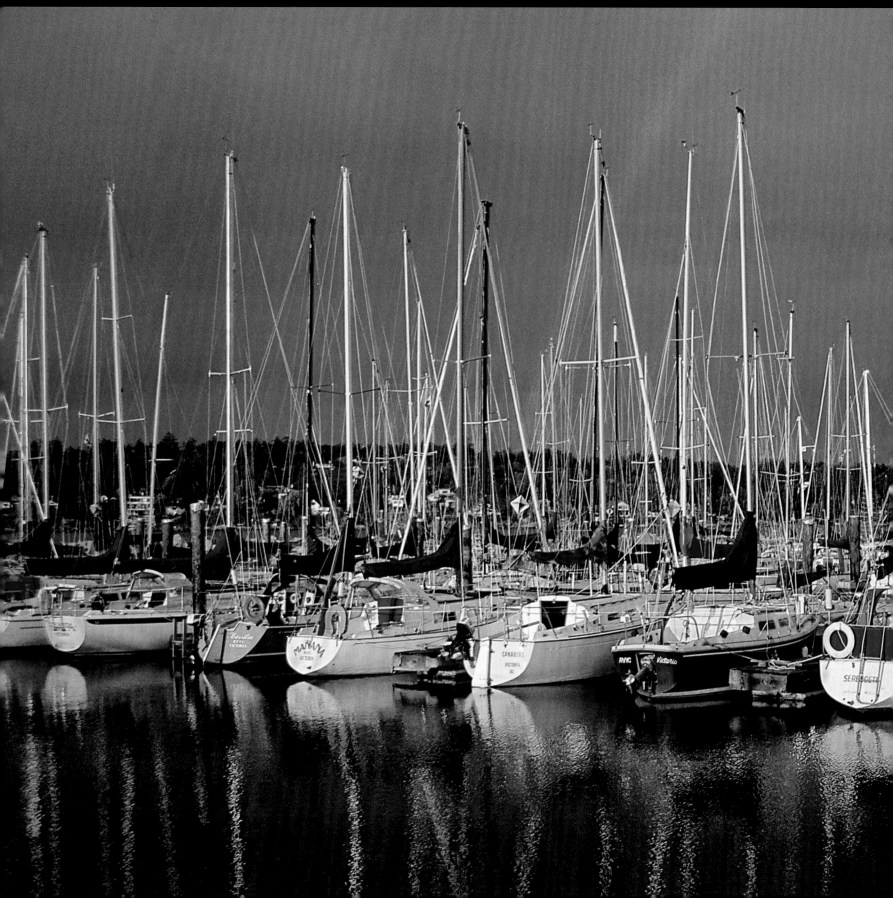

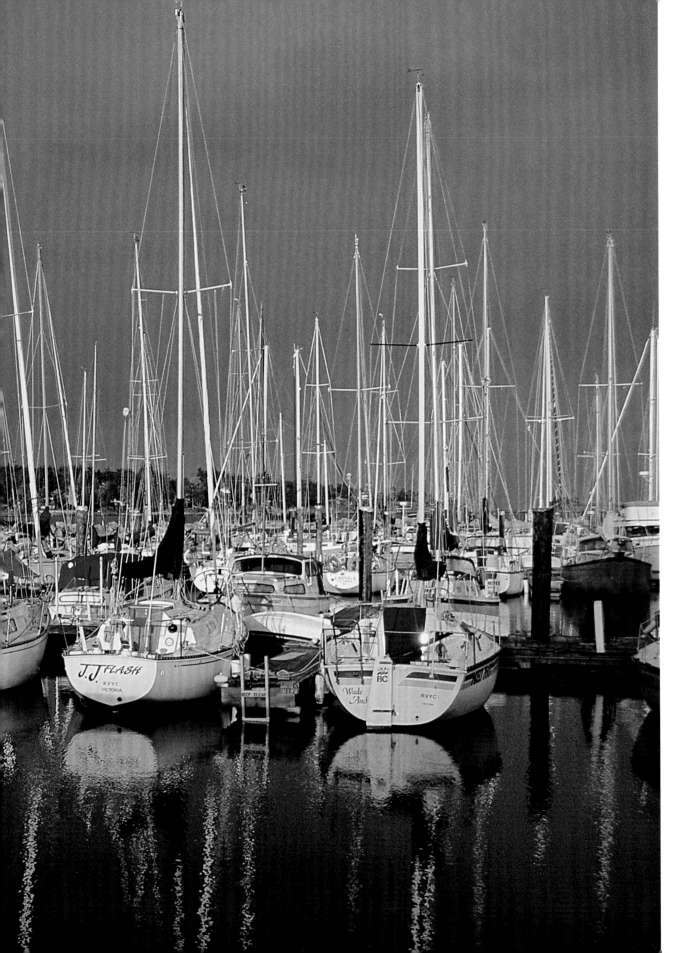

A childhood love of fishing prompted Robert Wright to launch an Oak Bay marina in 1962. The venture was so successful that Wright's Oak Bay Marine Group is now the continent's largest sport-fishing operation, with 18 divisions in three countries.

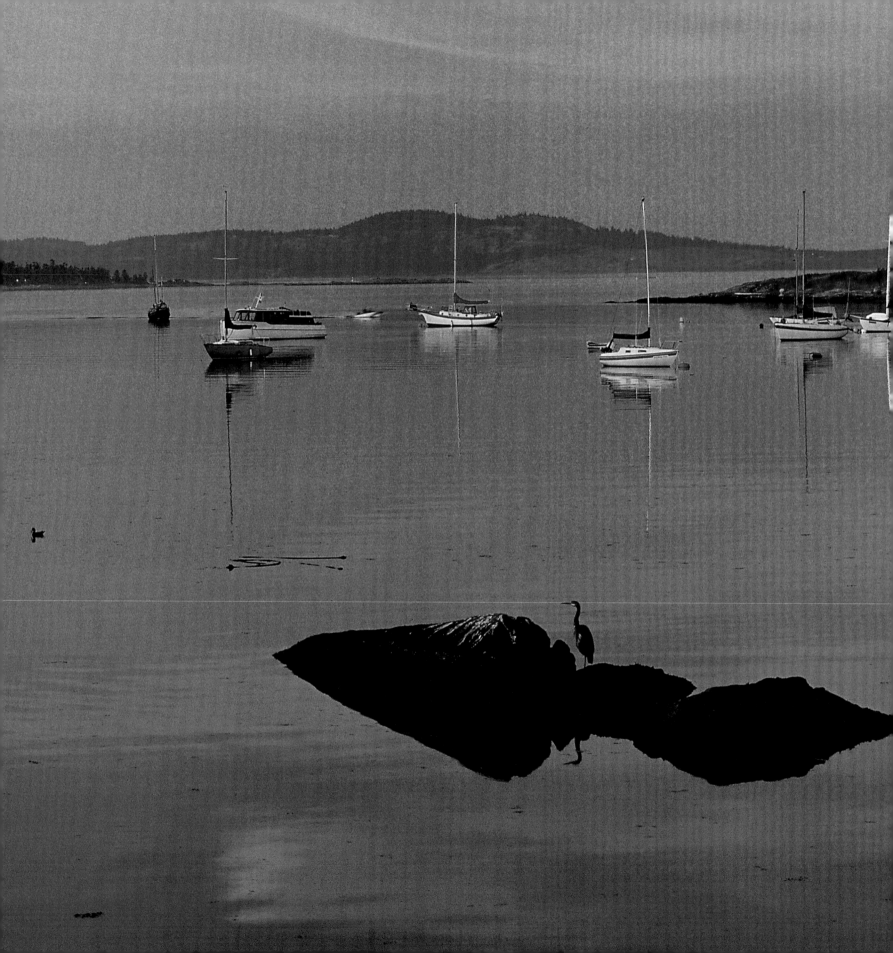

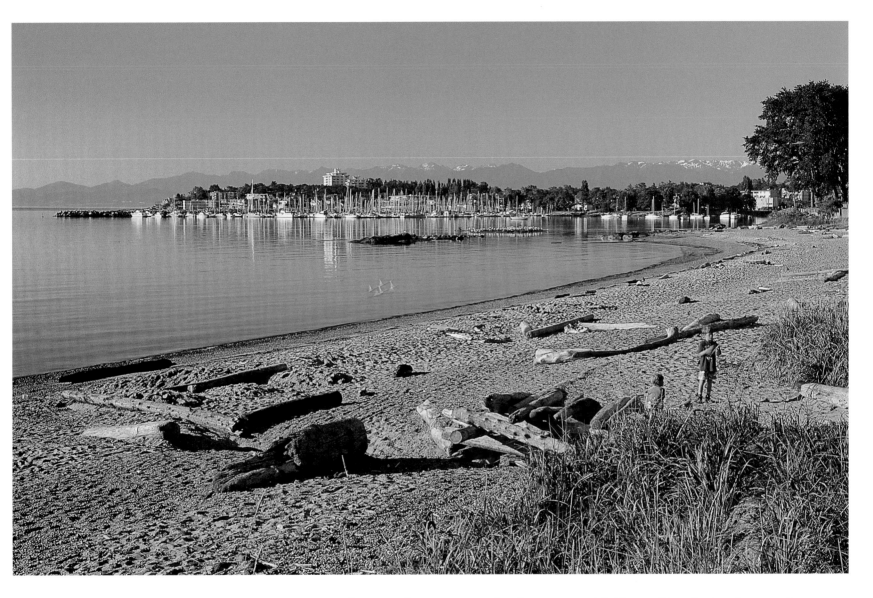

Oak Bay's favourite sunbathing spot, Willows Beach, is also perfect for an afternoon stroll, a competitive beach volleyball match, or an impromptu Frisbee game.

Pleasure boats bob in the quiet waters of Oak Bay. Residents have dubbed this municipality "behind the Tweed Curtain," a place where accents are often British and tea shops serve scones with clotted cream.

As well as catering
to the academic needs
of its 17,000 students,
the University of
Victoria draws more
than 30,000 people
to its campus each
year for plays, lectures,
films, art exhibitions,
sporting events,
and more.

56

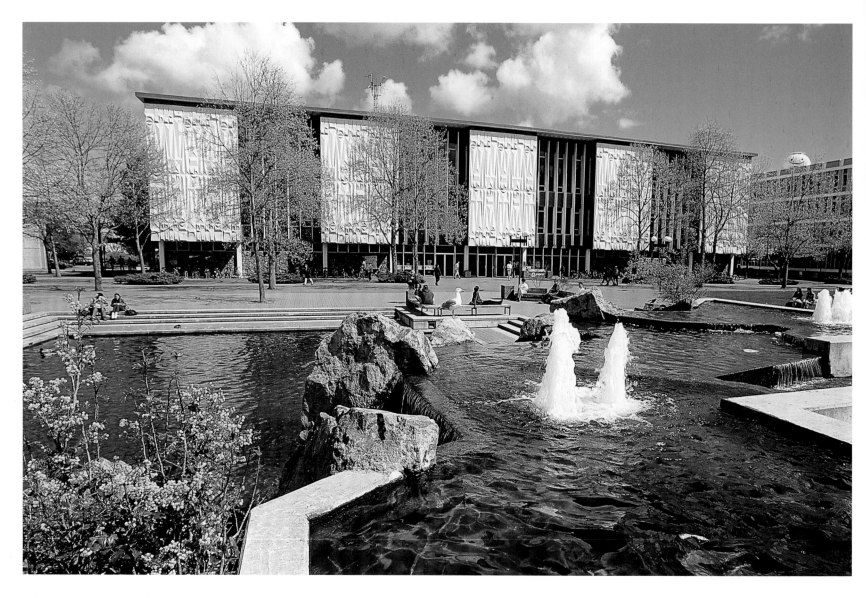

The University of Victoria's roots stretch back to 1903, when it was founded as an affiliate of Montreal's McGill University. UVic moved to its current 160-hectare (395-acre) Gordon Head campus in 1963.

Victoria birdwatchers have recorded sightings of more than 380 species in and around the city. Great blue herons are easy to spot, especially at Saanich's Swan Lake Christmas Hill Nature Sanctuary where they wait, perfectly still, in the shallow waters.

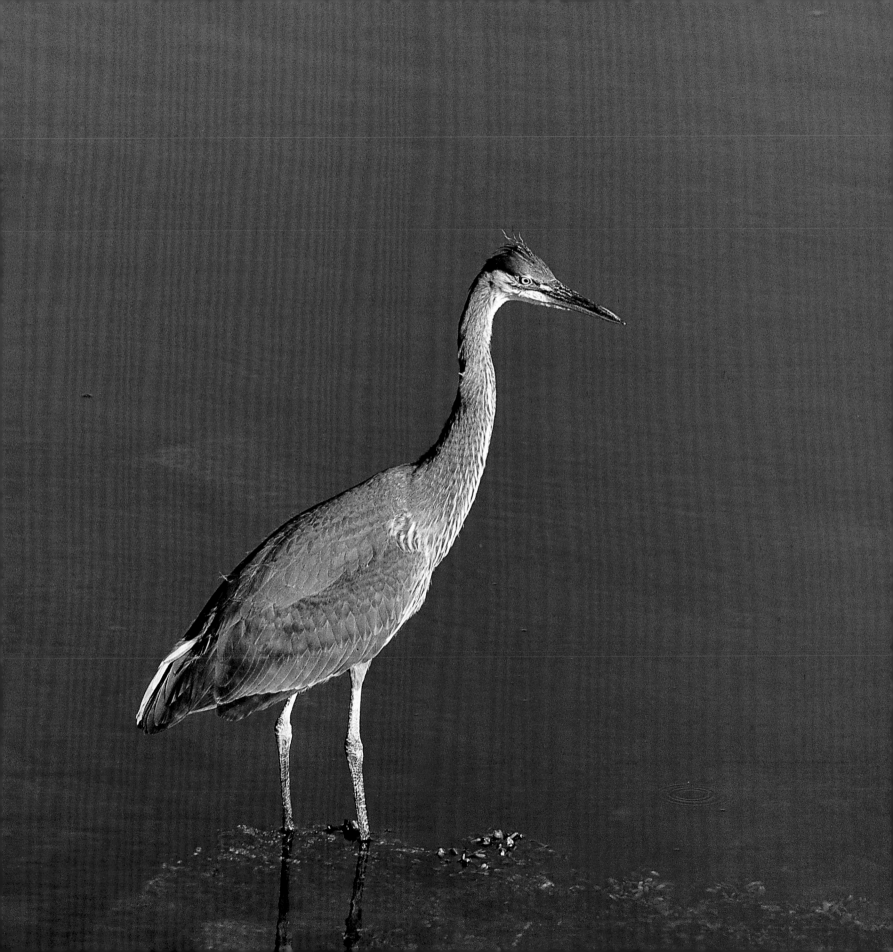

The provincial government founded B.C. Ferries in 1960 to shuttle vehicles and passengers between Vancouver and Vancouver Island. Today, the service is one of the largest in the world, with a fleet of 40 vessels serving 46 ports.

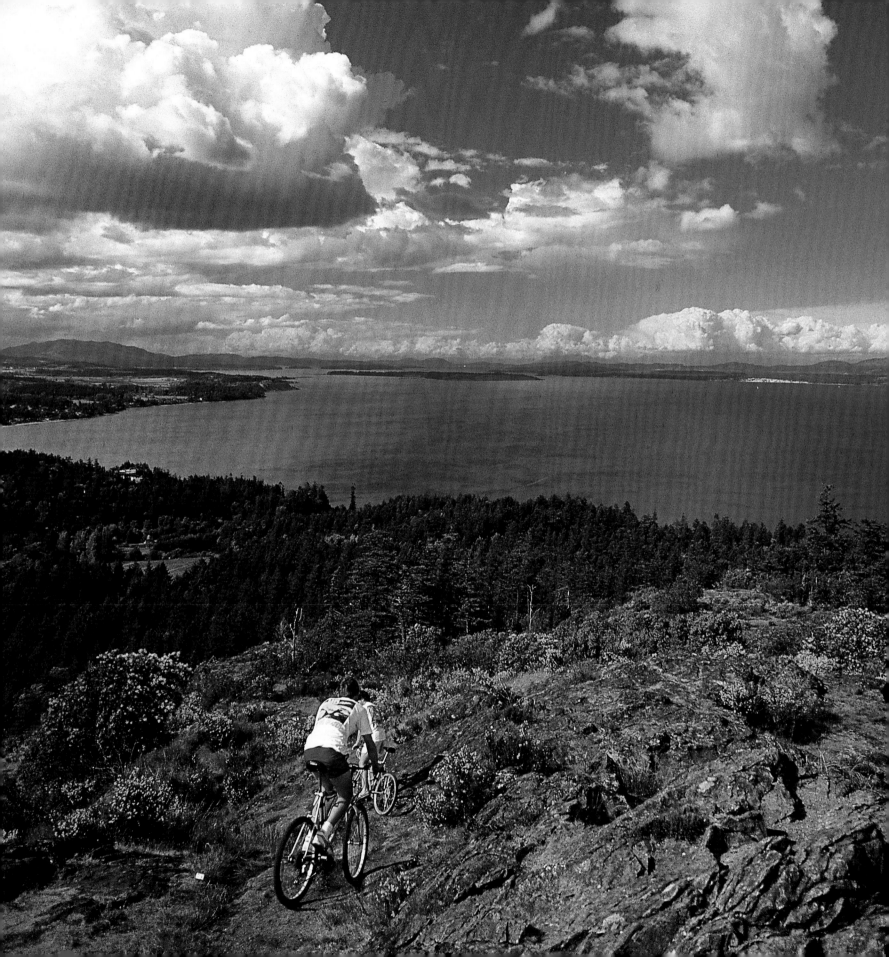

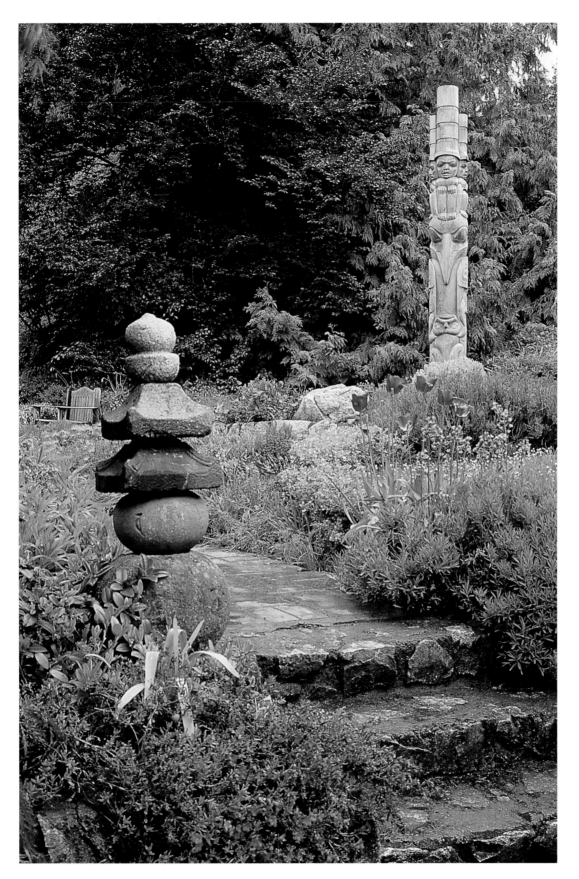

At Ravenhill Farm on the Saanich Peninsula, each season brings a new harvest of herbs and vegetables. Home to chef Noël Richardson and gardener Andrew Yeoman, the farm opens its doors to curious visitors each Sunday.

FACING PAGE—
Adventure-seekers escape on a mountain-biking excursion to nearby Mount Douglas Park. This woodland preserve of cedar and Douglas fir offers panoramic views of Cordova Bay to the north and the city centre to the south.

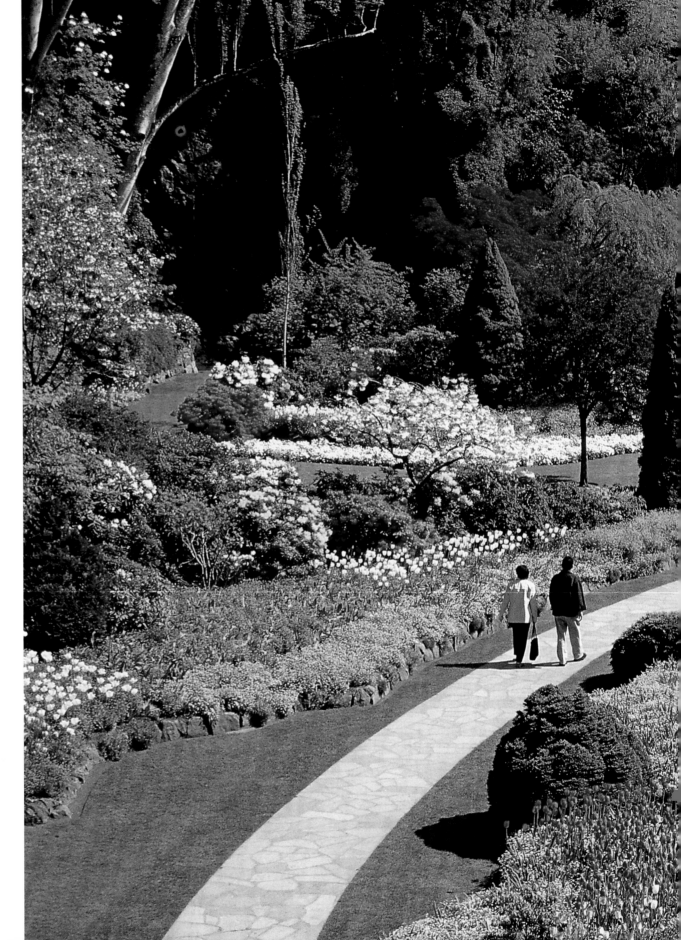

The lush Sunken Garden at Butchart Gardens covers a former limestone quarry owned by the Butchart family. In the early 1900s, Jenny Butchart transformed the land into luxuriant gardens, which today attract a million visitors each year.

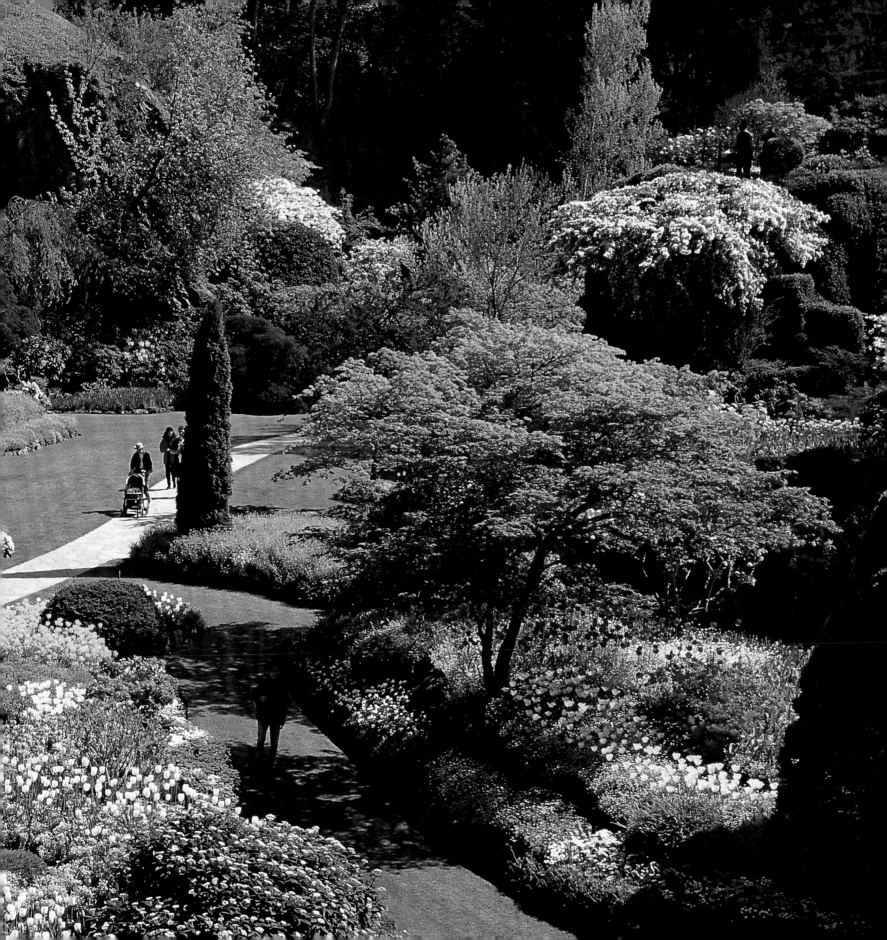

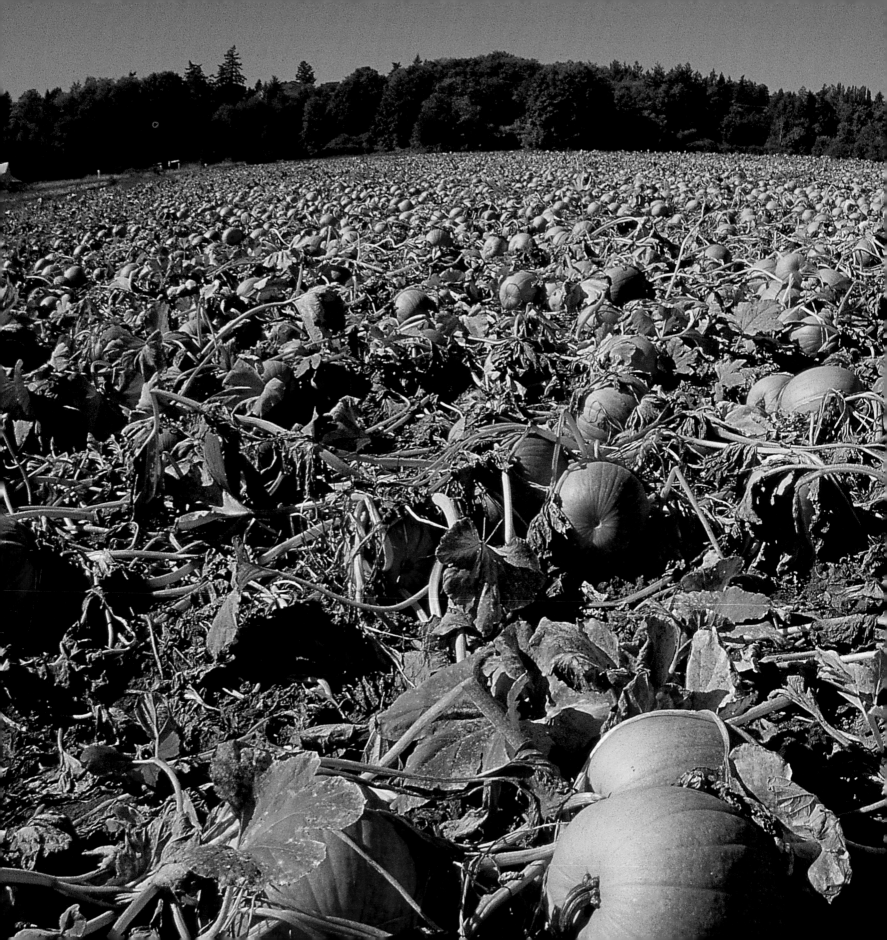

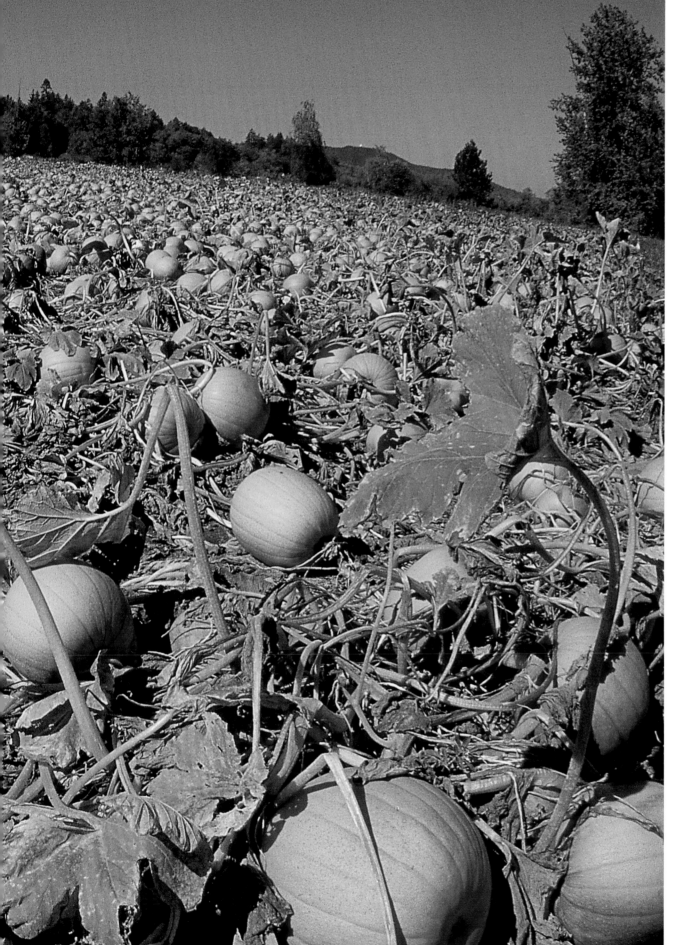

Many of the farms on the Saanich Peninsula are small—between four and 28 hectares (10 and 70 acres)—and family-owned. Crops range from the traditional, such as poultry and produce, to the experimental, including llamas, ostriches, and fallow deer.

67

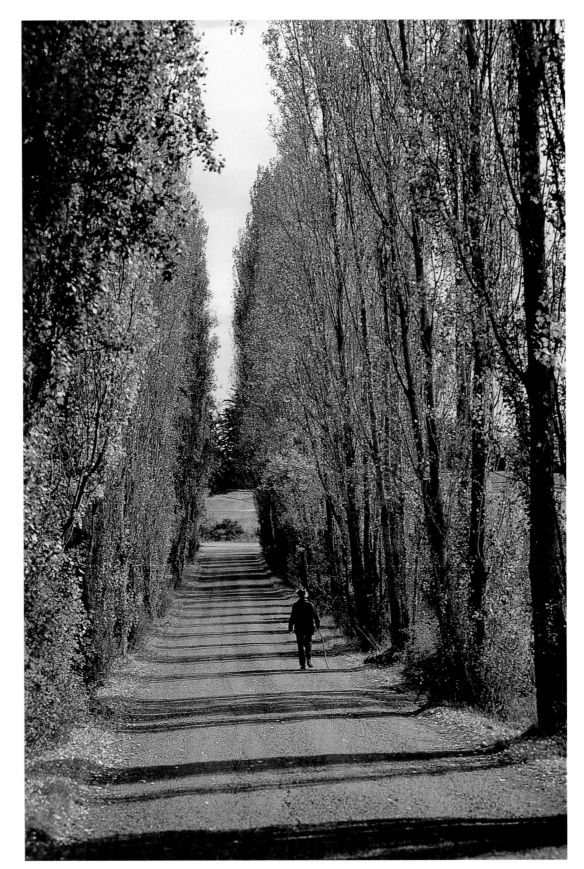

Many of the Saanich Peninsula's main roads were once stagecoach routes, connecting Sidney, Central Saanich, and North Saanich to Victoria. Quiet, tree-lined lanes lead from the main thoroughfares through farmland and hidden residential neighbourhoods.

Known for its quiet farms and vibrant flower harvests, the Saanich Peninsula extends north from the city into Georgia Strait. The name *Saanich* stems from a Coast Salish word meaning "fertile soil," the secret behind the region's annual crop of more than 13 million daffodils.

In 1891, four brothers of the Brethour family pooled their land— 200 hectares (500 acres) collectively— and incorporated the township of Sidney on the Saanich Peninsula. Within a year, the new settlement included a post office, a hotel, and a general store.

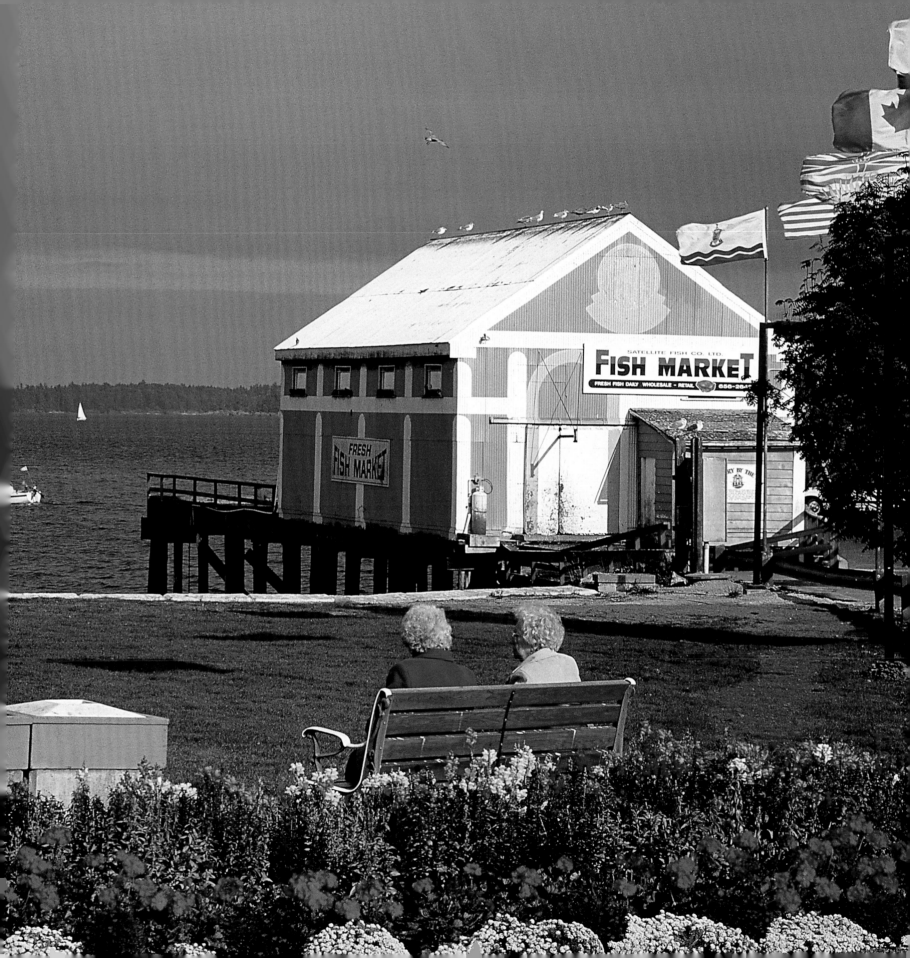

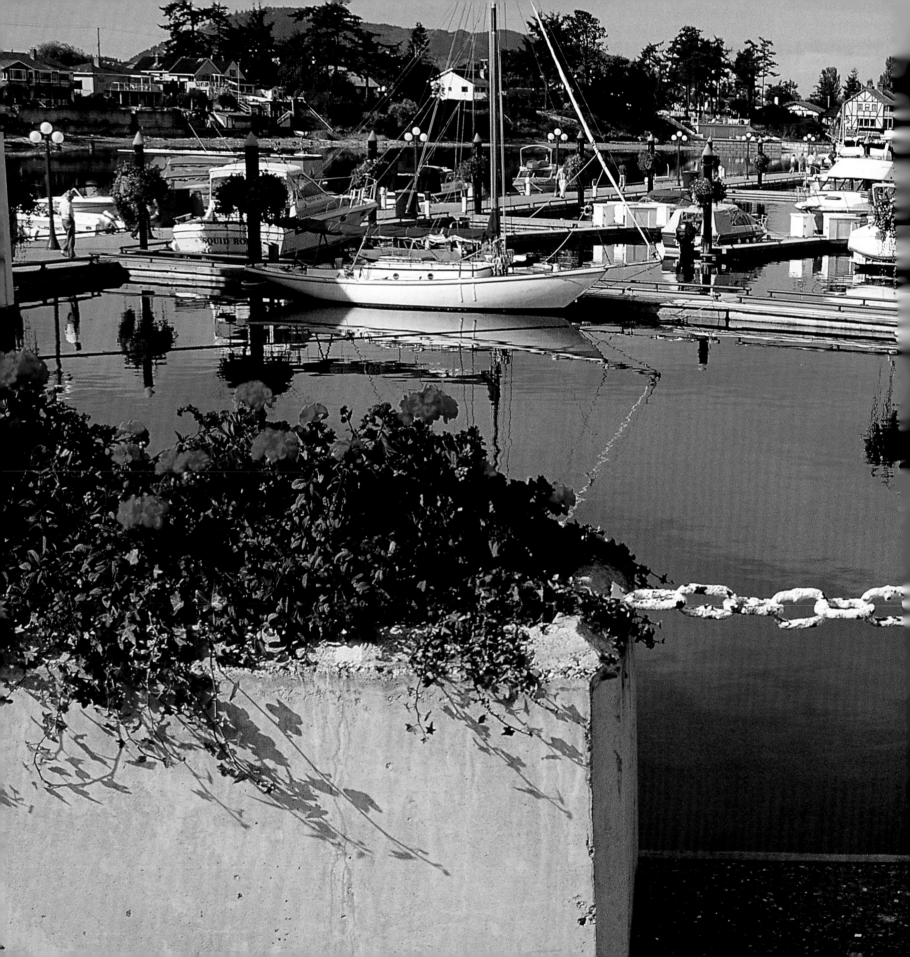

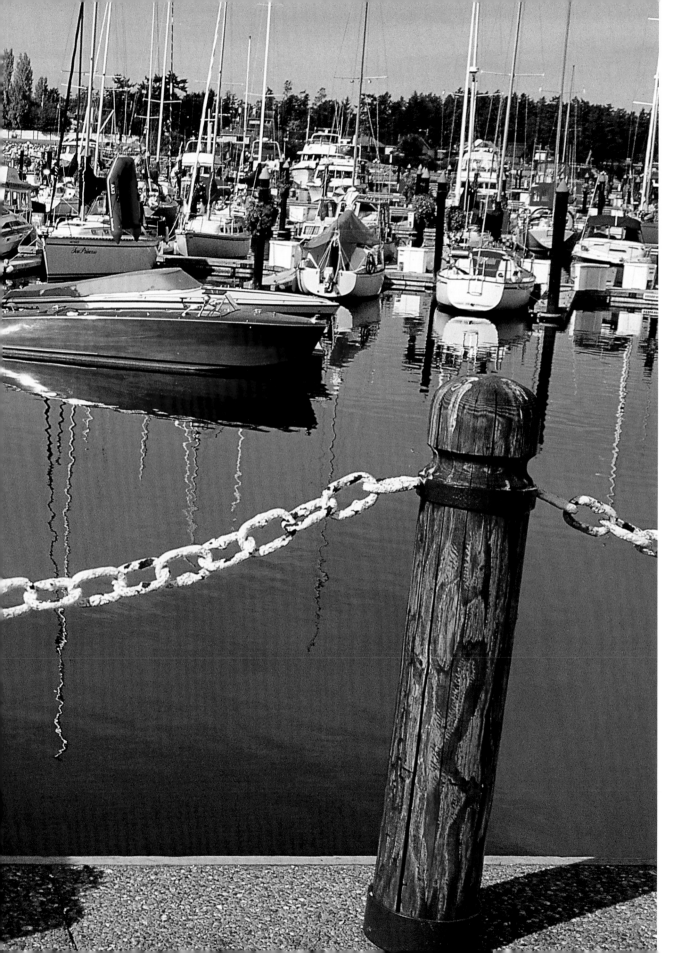

Home to about 11,000 people, Sidney is often seen as a quiet retirement community. However, Beacon Avenue offers an array of interesting shops, expansive marinas attract more boaters each year, and Sidney Spit Marine Provincial Park lies just offshore.

73

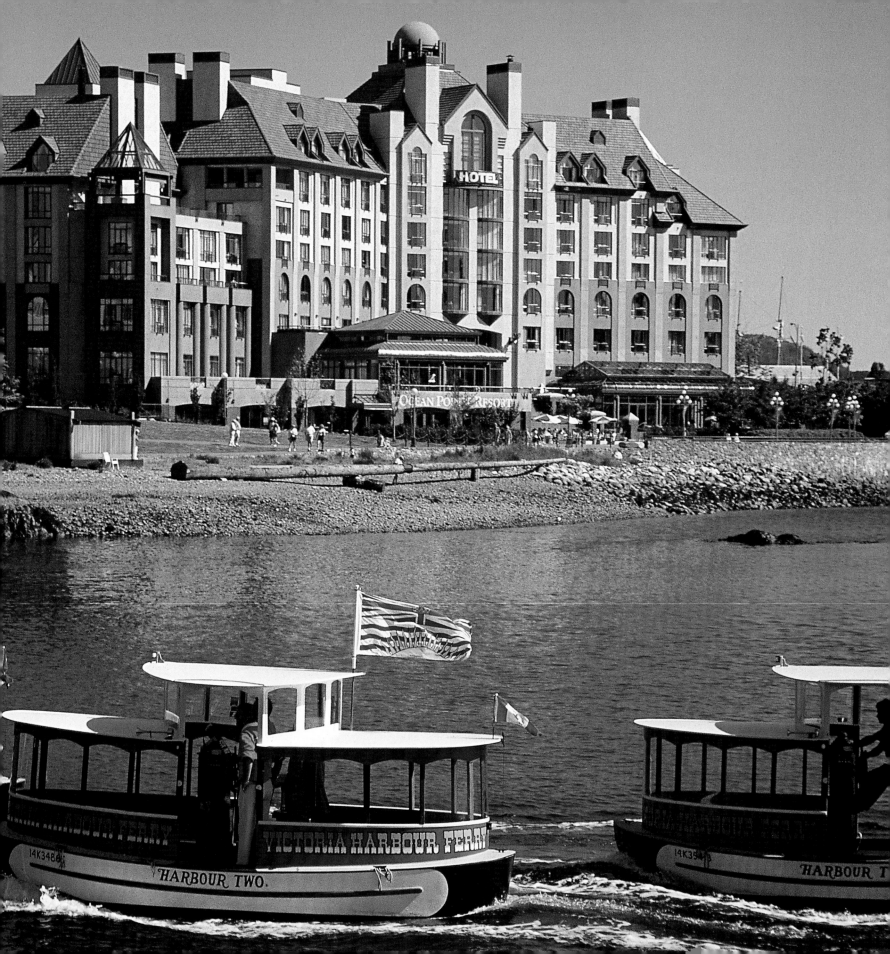

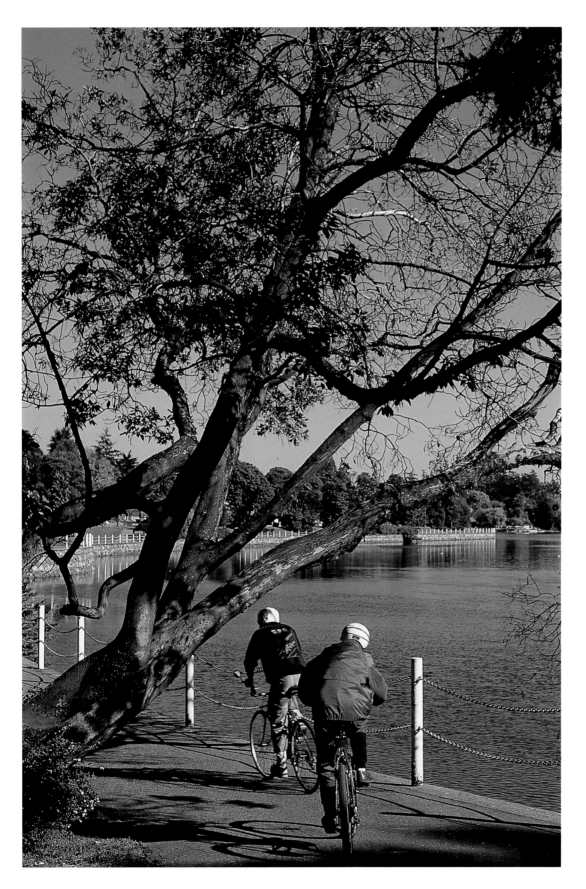

The Songhees land was once a native settlement, but the area was sold to the B.C. government in 1910. After a period as an industrial area, it has been developed into a waterfront neighbourhood with condominiums and a seaside walkway.

FACING PAGE–
The Delta Victoria Ocean Pointe Resort and Spa, overlooking the Inner Harbour, features 247 luxurious rooms along with two restaurants, a lounge, a ballroom, conference facilities, a fitness centre, and a full-service spa.

The calm waters of the Gorge Waterway have attracted boaters since the early 1900s, when this was Victoria's premier destination for a romantic afternoon boat ride or a competitive rowing regatta. Dragonboat competitions and weekly paddling races now continue the tradition.

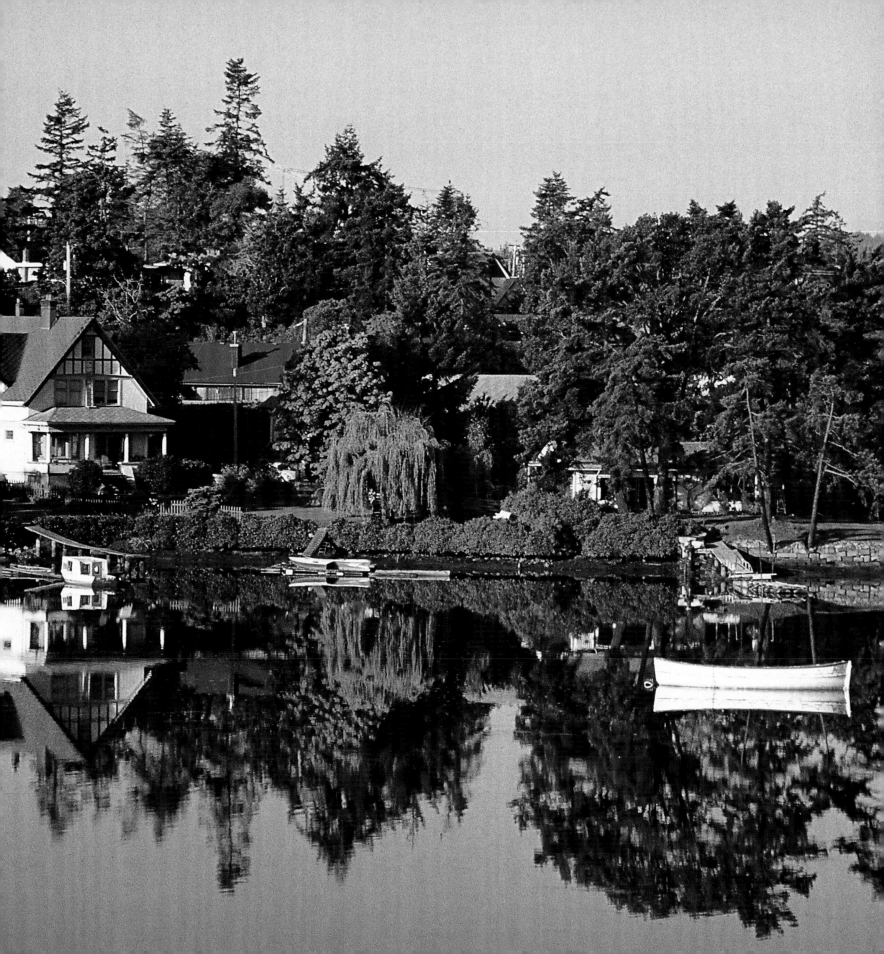

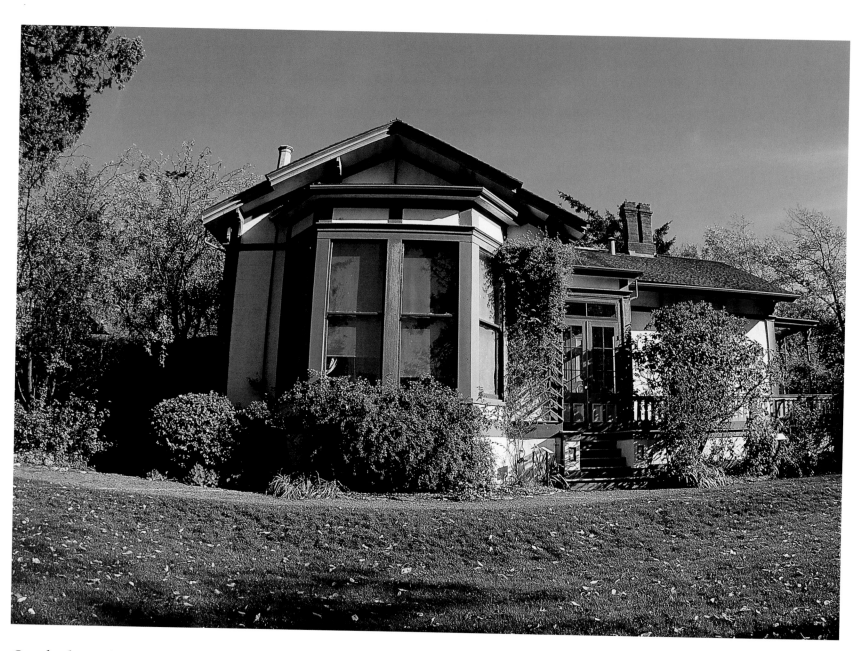

Overlooking the Gorge, Point Ellis House was once home to Peter O'Reilly, gold rush magistrate and commissioner, who gathered around him the most prominent of nineteenth-century Victoria society.

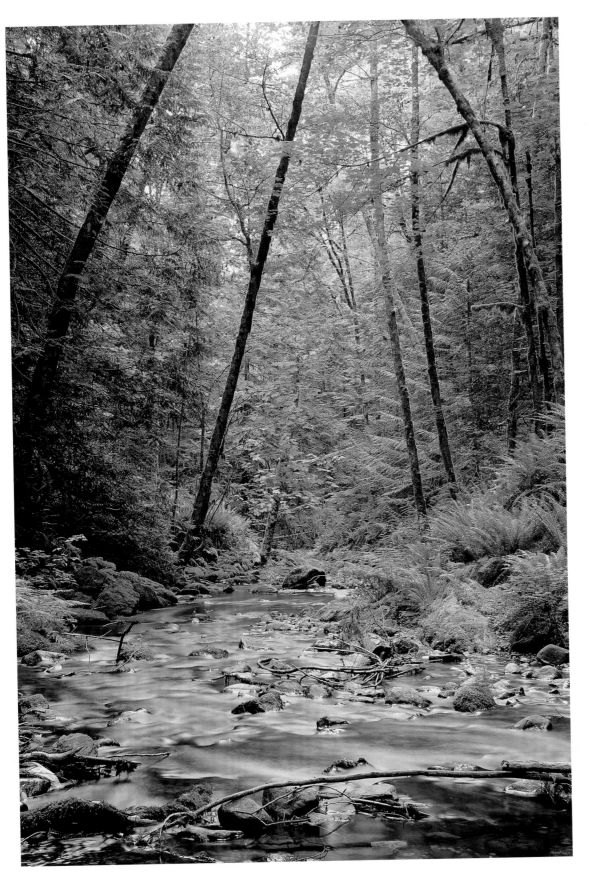

Once the fishing grounds of First Nations, then a mecca for gold seekers, Goldstream is now a provincial park, established in 1958. Trails within the preserve lead from the peak of Mount Finlayson, one of the highest mountains on Vancouver Island, to the boardwalks of a saltwater marsh.

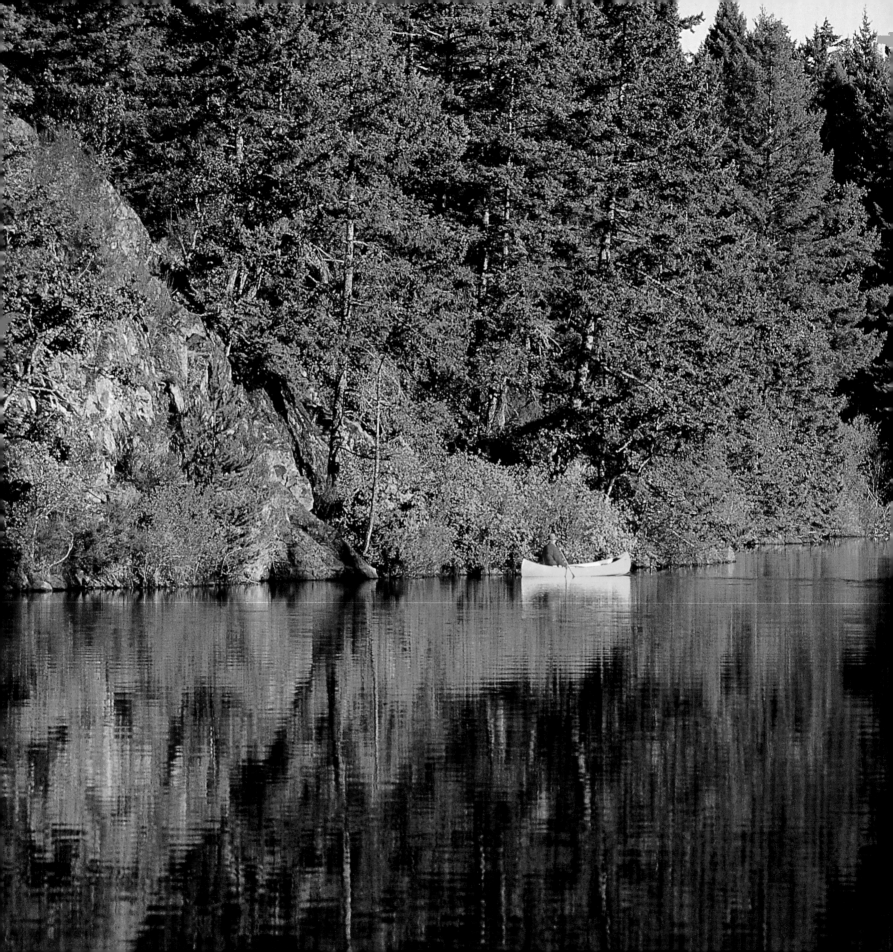

To many Victoria residents, summer means afternoons at Thetis Lake Regional Park, just 11 kilometres (7 miles) from downtown. Sunbathers lounge on the beaches, while paddlers launch canoes and kayaks in search of more isolated bays. The parkland surrounding the lake includes a Garry oak ecosystem and Douglas fir forest.

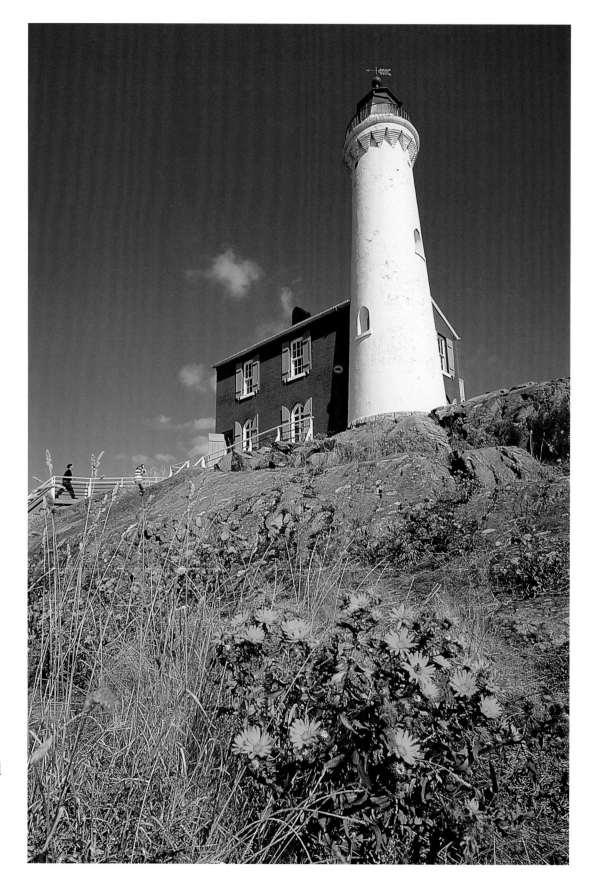

Built in 1860, Fisgard Lighthouse was the first beacon on Canada's west coast. Nearby Fort Rodd Hill National Historic Site commemorates the artillery fort in operation here from 1878 to 1956, dedicated to the protection of Victoria and the Esquimalt naval base.

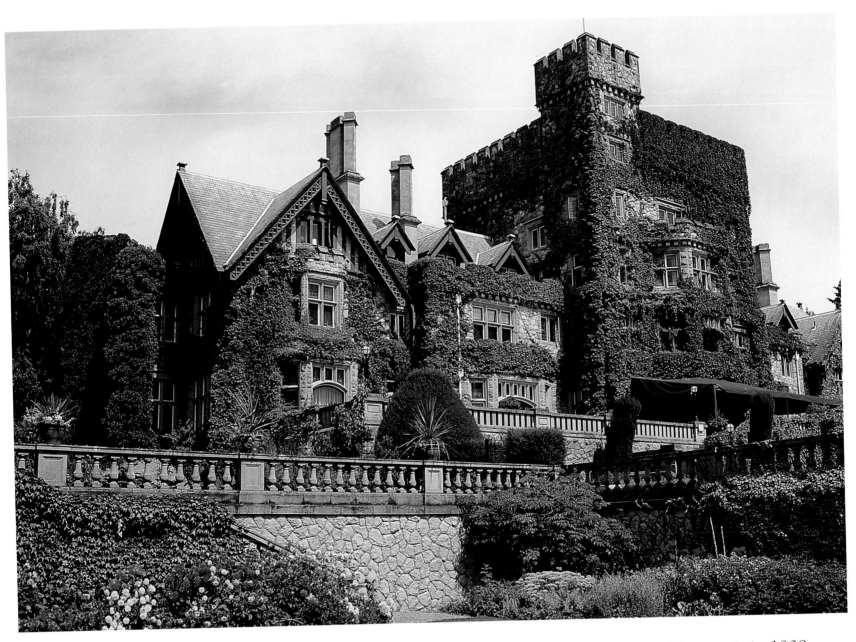

Commissioned by Lieutenant-Governor James Dunsmuir in 1908, Hatley Castle was the centrepiece of a country estate. The federal government purchased the land in 1940 and it is now the administrative centre of Royal Roads University.

According to story-
tellers, James Dunsmuir
told his builders,
"Money doesn't matter.
Just build what I want."
His estate included
housing for the 80 to
120 gardeners needed
to maintain the
grounds. From the
1940s to the 1990s,
the estate served as a
military college, yet
some of Dunsmuir's
elaborate gardens
remain.

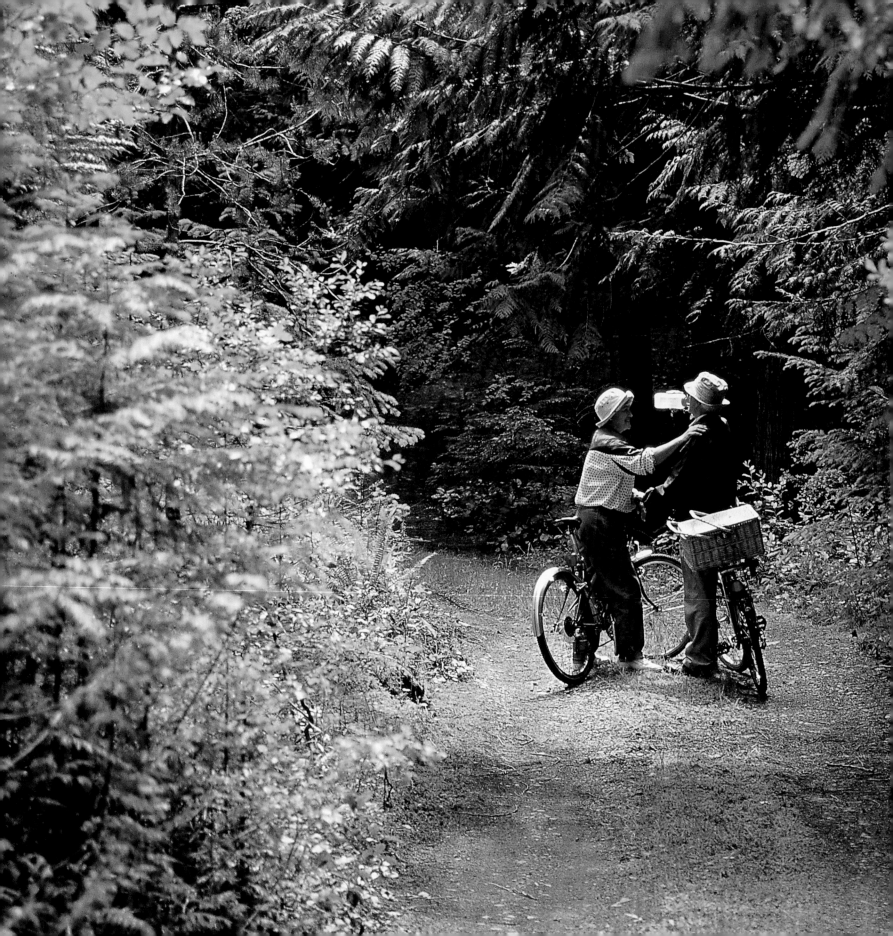

The Galloping Goose
Regional Trail—
known locally as
"the Goose"—leads
cyclists, walkers, and
horseback riders along
a historic railway
bed for 60 kilometres
(37 miles) from the
heart of Victoria to
the wilderness of
Sooke. High wooden
trestles, hidden lakes
and marshes, and
forests of Douglas fir
wait along the way.

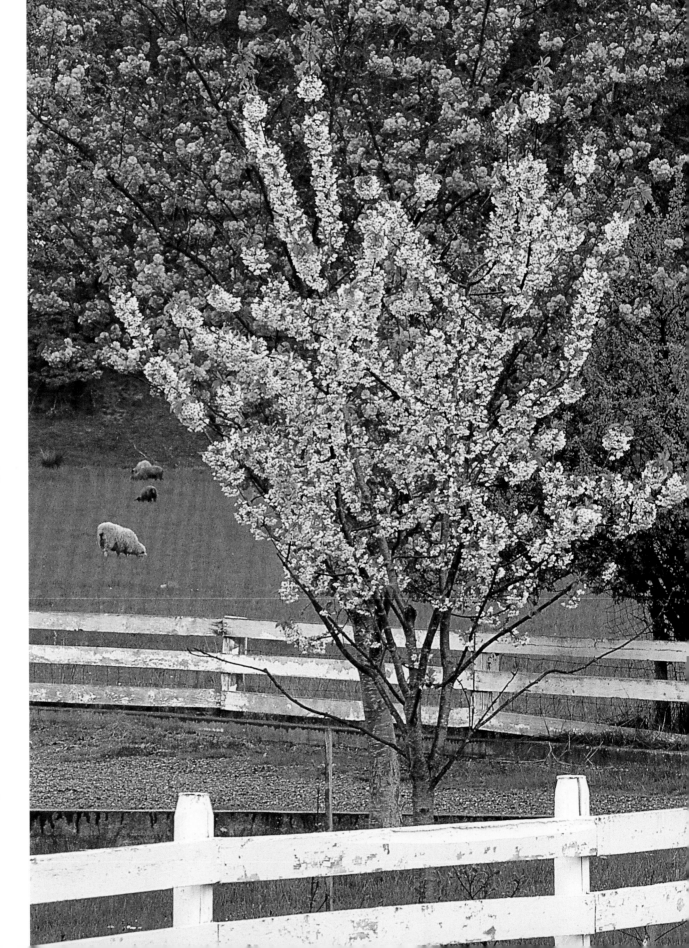

The rural beauty of Metchosin belies its name, which means "place of the stinking fish." Local native people named the region after a dead whale washed up on shore. Thomas Argyle, an engineer on a surveying mission for Britain, became one of Metchosin's first European settlers when he claimed 60 hectares (150 acres) here in 1863; the community now numbers 5,000.

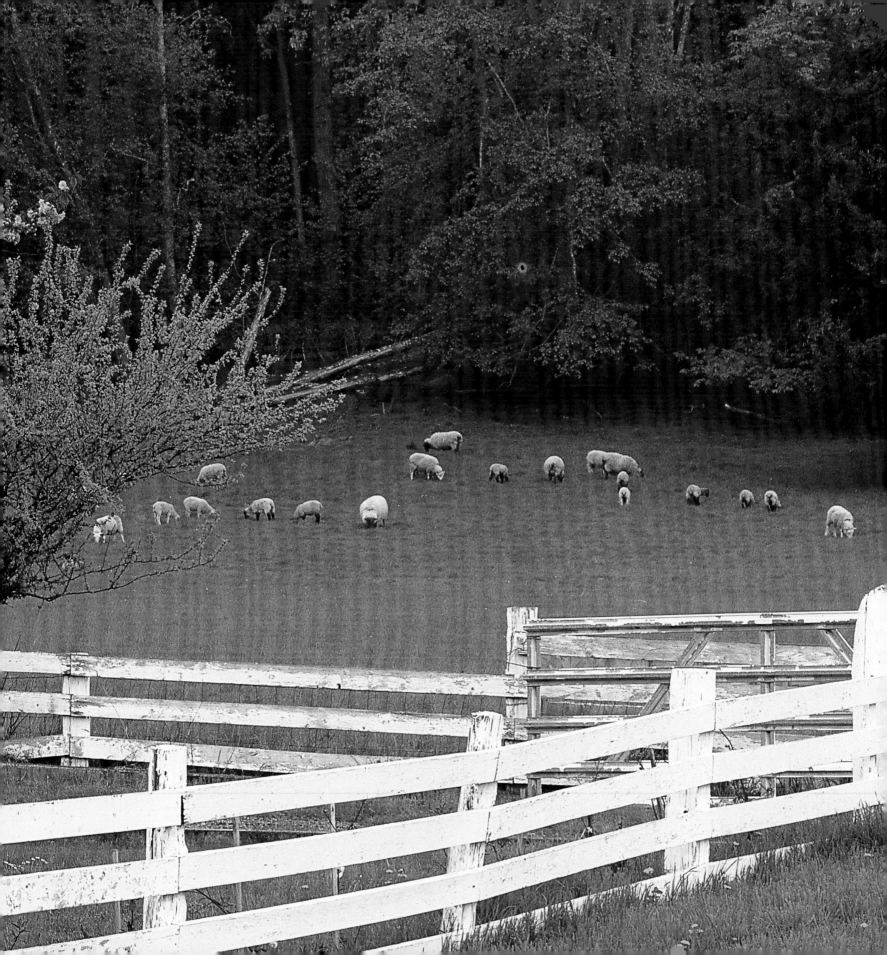

The largest of 29 preserves maintained by the Capital Regional District, East Sooke Regional Park encompasses 1,422 hectares (3,514 acres) of lush coastal forest, open meadows with native shrubs, and rocky beaches. A six-hour hiking trail traces the shoreline.

FACING PAGE–
Visitors driving the back roads of Metchosin are likely to find the shops of potters and artists, small family farms selling organic produce and free-range eggs, and charming historic buildings such as this church.

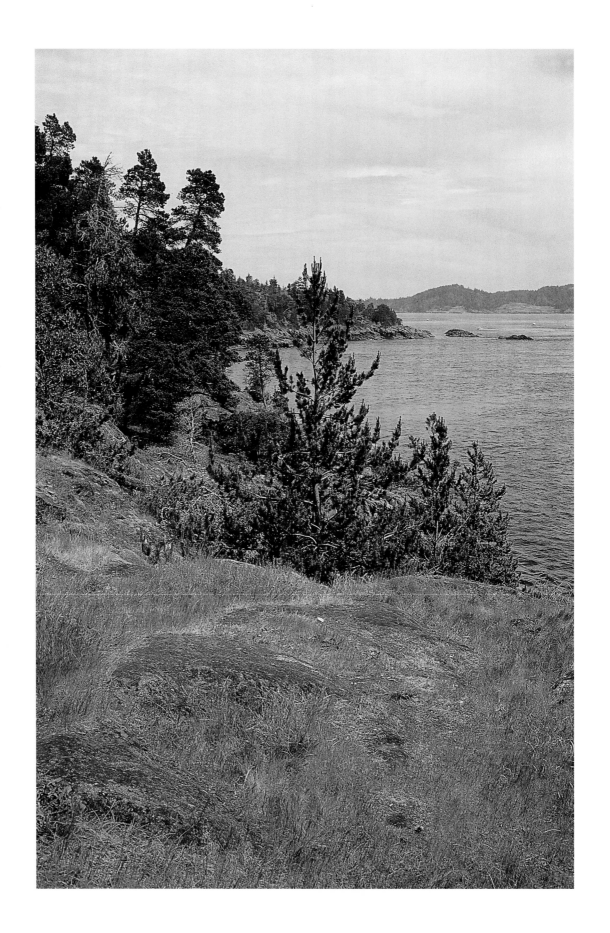

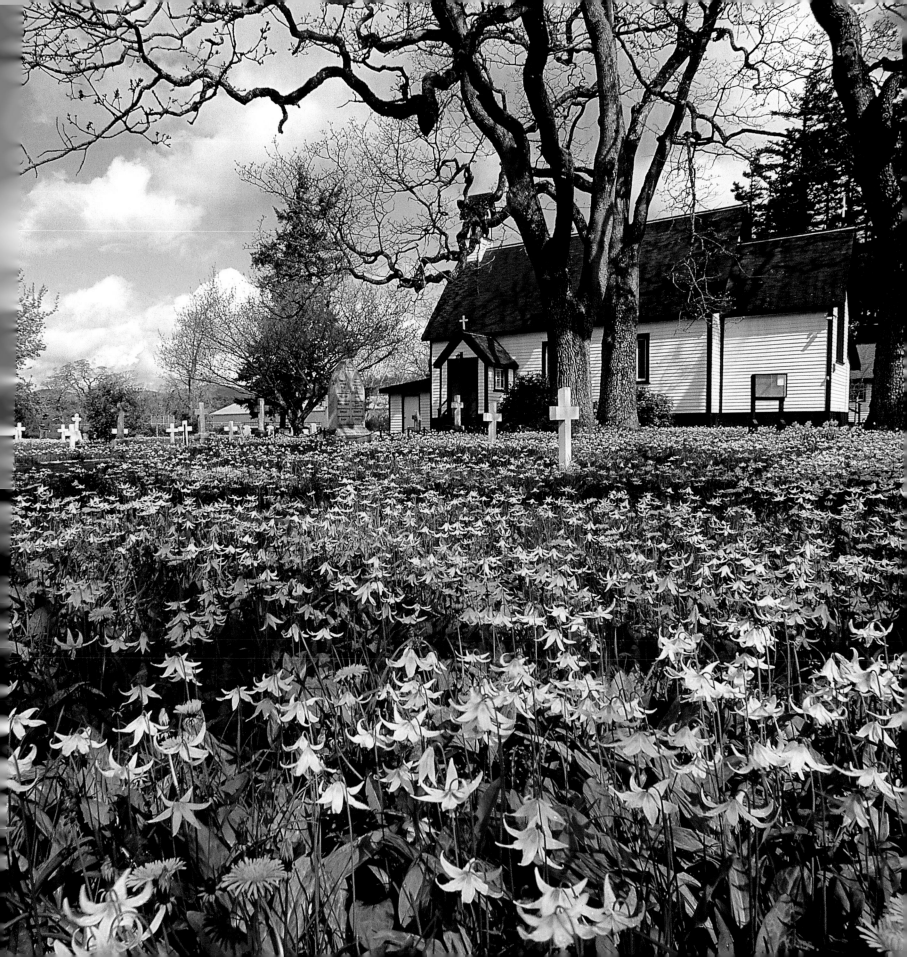

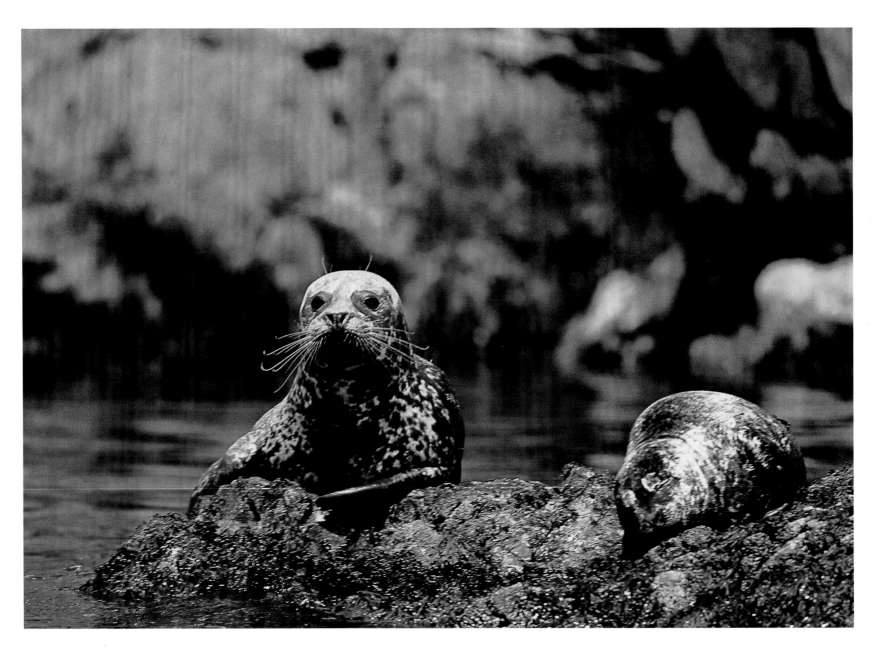

A harbour seal basks in spring sunshine on the shores of Sooke.
Adult seals, which can weigh 60 to 80 kilograms (130 to 175 pounds),
feed on salmon, rockfish, octopus, and other marine life. Often seen
as a pest (and a competitor) by commercial fishers, the rotund creatures
charm the tourists.

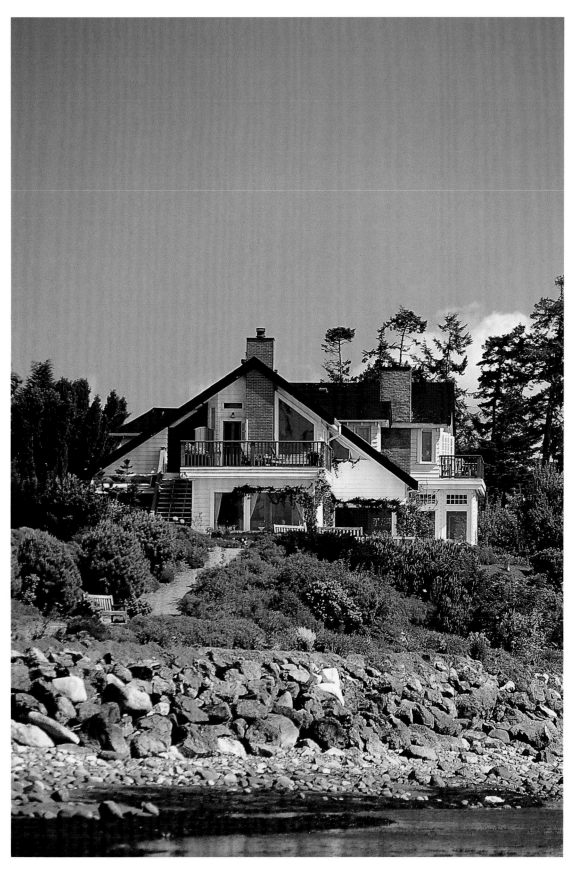

For more than two decades, guests from around the world have retreated to the sumptuous rooms of Sooke Harbour House. Here they enjoy gourmet meals made from organic produce and edible flowers from the inn's gardens, and gorgeous coastal views.

The sparkle of the night skyline, streets lined with heritage buildings, secluded garden walks, and quiet cafés are all part of the romance of Victoria, an atmosphere that attracts hundreds of honeymooners each year.

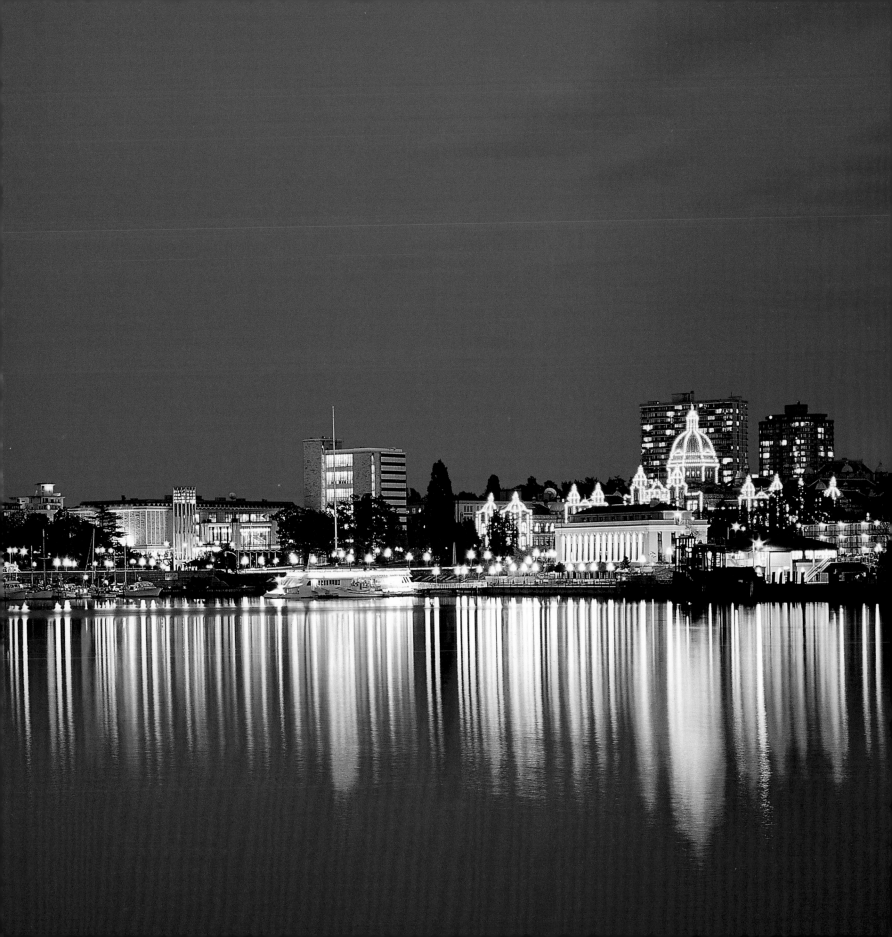

Photo Credits